Dreaming Light

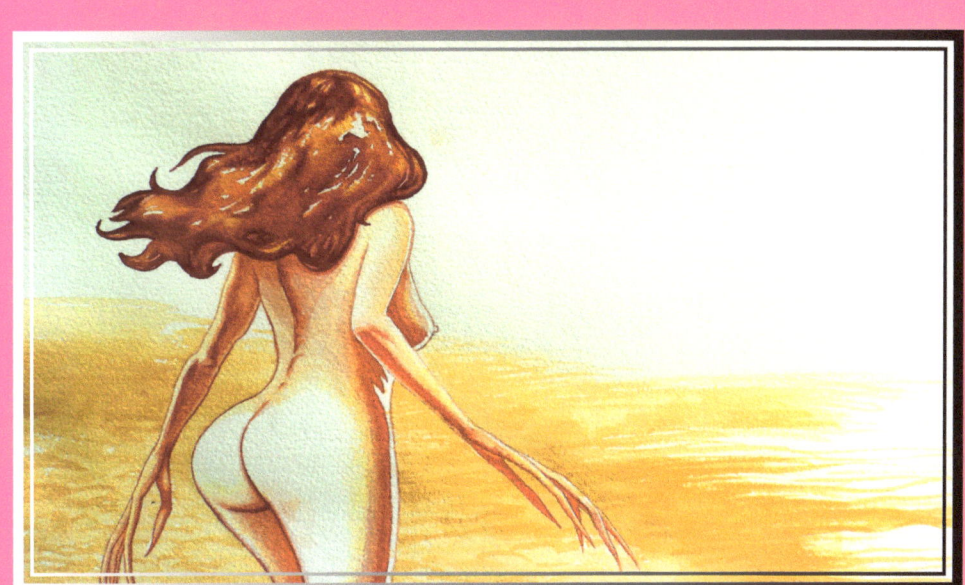

The Fantasy Art of
DX Stone

Nuance Press

Dreaming Light: The Fantasy Art of D X Stone Volume II
Copyright © 2012 Nuance Press
All rights reserved.

ISBN-13: 978-0615621067

www.nuancepress.com

FOREWORD:

DREAMERS

We Dreamers
In a single steady flight of moments:

We stalk and slay the phantoms of our youth
We strive and strut and spit unseemly curse
We hurl our stones at Gods as yet unborn
And climb or cling within this World of Walls

We rend the very fabric of cold Truth
We spin and sweat and weave in line and verse
A new, whole cloth of Beauty and adorn
The Universe with our graffiti scrawls

We Dreamers
In single steady moments
Of Flight

D X Stone

In a Wonderland they lie,

Dreaming as the days go by,

Dreaming as the summers die:

Ever drifting down the stream-

Lingering in the golden gleam-

Life, what is it but a dream?

Lewis Carroll

Encounter – 1985, oil on canvas

THE FANTASY ART OF D X STONE

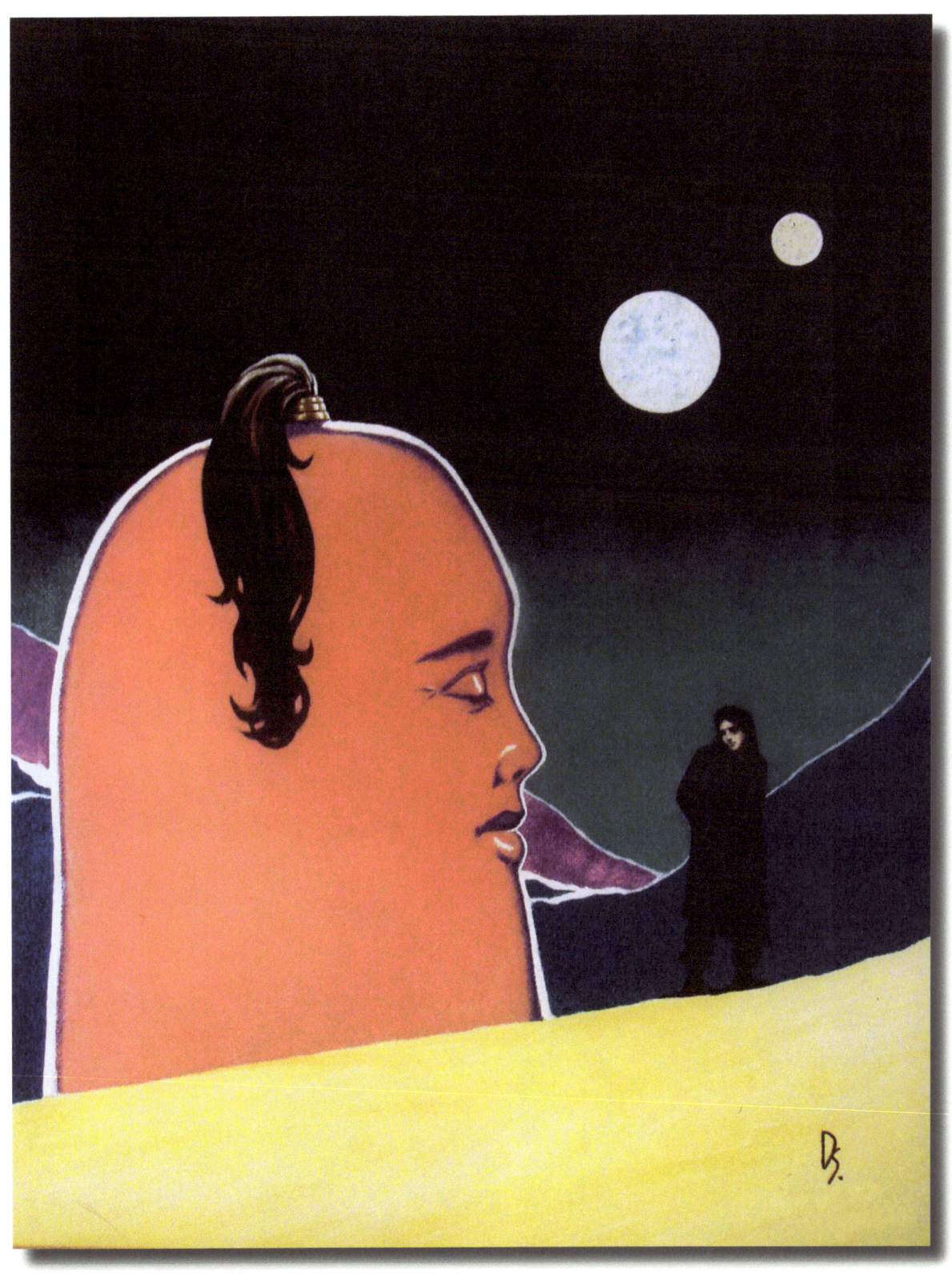

DREAMING LIGHT

"Do you think I've gone round
 the bend?"

"I'm afraid so.
You're mad,
bonkers, completely
off your head.

But I'll tell you a secret. All the best
 people are."

 Lewis Carroll

Redhead – 2007, watercolor

THE FANTASY ART OF D X STONE

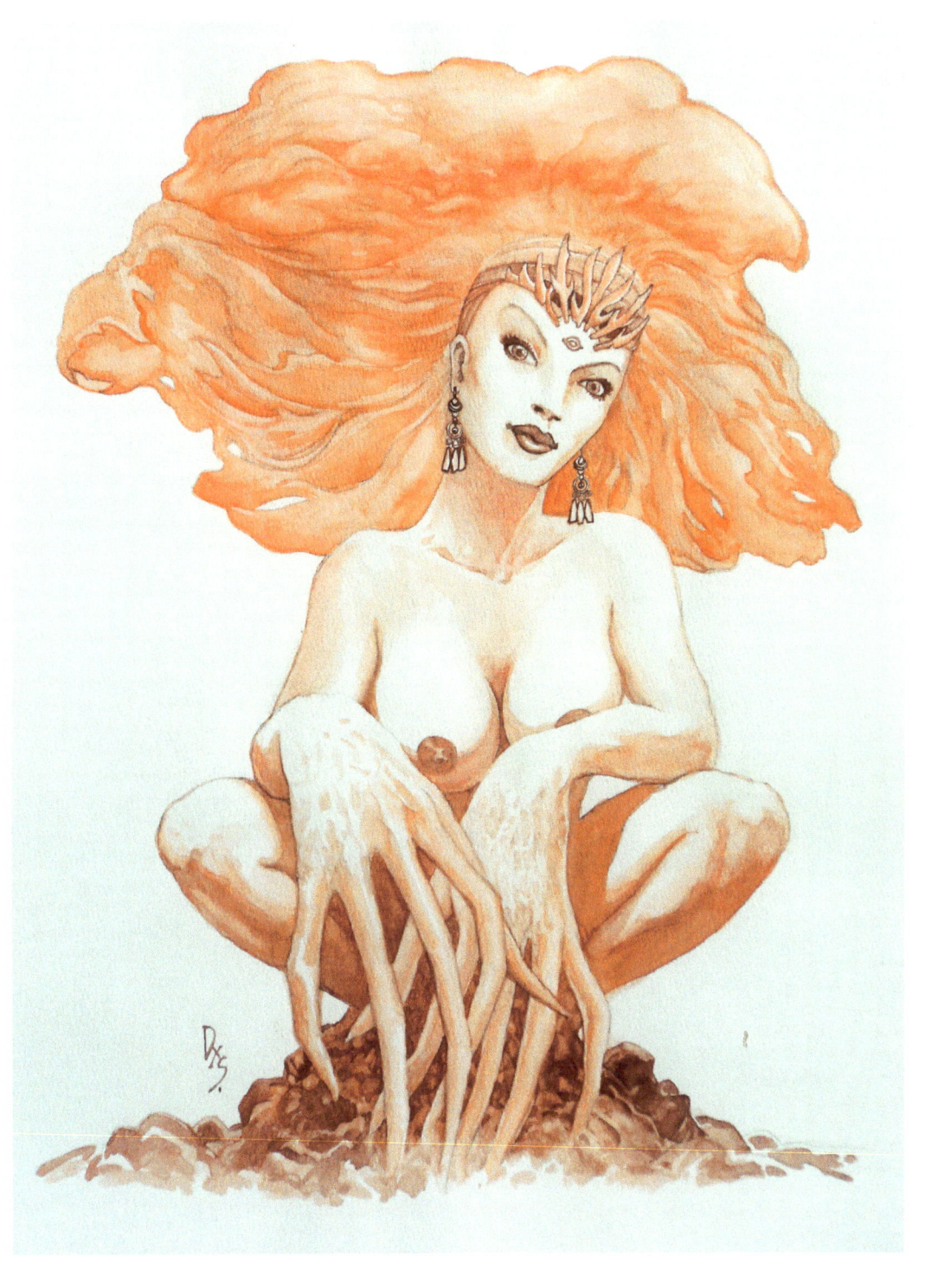

DREAMING LIGHT

Dream as if you'll live forever.
Live as if you'll die today.

James Dean

Dream no small
dreams for they
have no power
to move the
hearts of men.

Johann Wolfgang von Goethe

I dream of painting and
then I paint my dream.

Vincent Van Gogh

Medicine Man – 1976, oil on canvas

THE FANTASY ART OF D X STONE

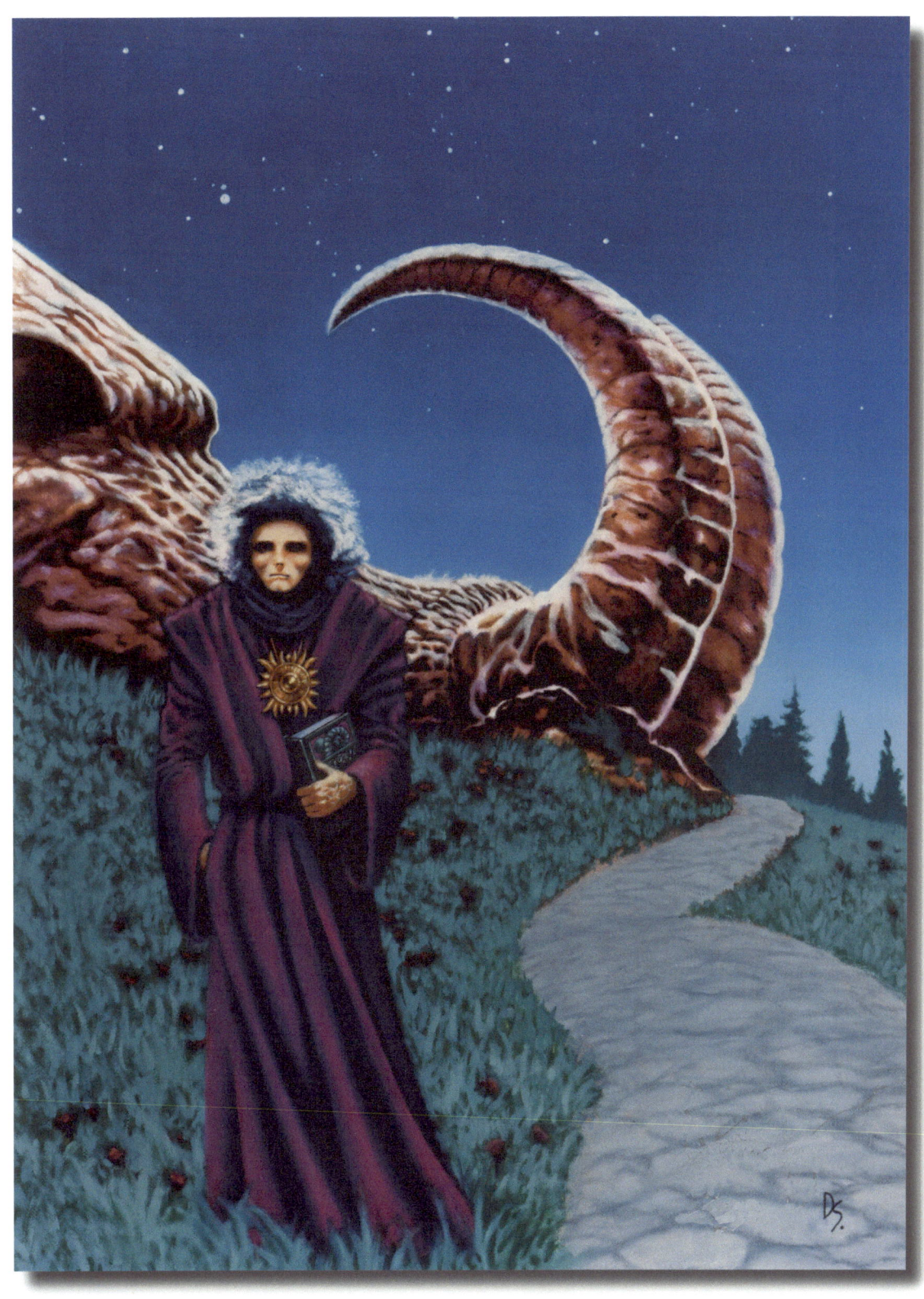

DREAMING LIGHT

"She's a replicant, isn't she?"

"I'm impressed. How many questions does it usually take to spot one?"

"I don't get it, Tyrell—"

"How many questions?"

"Twenty, thirty, cross-referenced."

"It took more than a hundred for Rachel, didn't it?"

"She doesn't know."

"She's beginning to suspect, I think—"

"Suspect? How can it not know what it is?"

Deckard and Tyrell, Blade Runner

The Empress - 2008, watercolor

THE FANTASY ART OF D X STONE

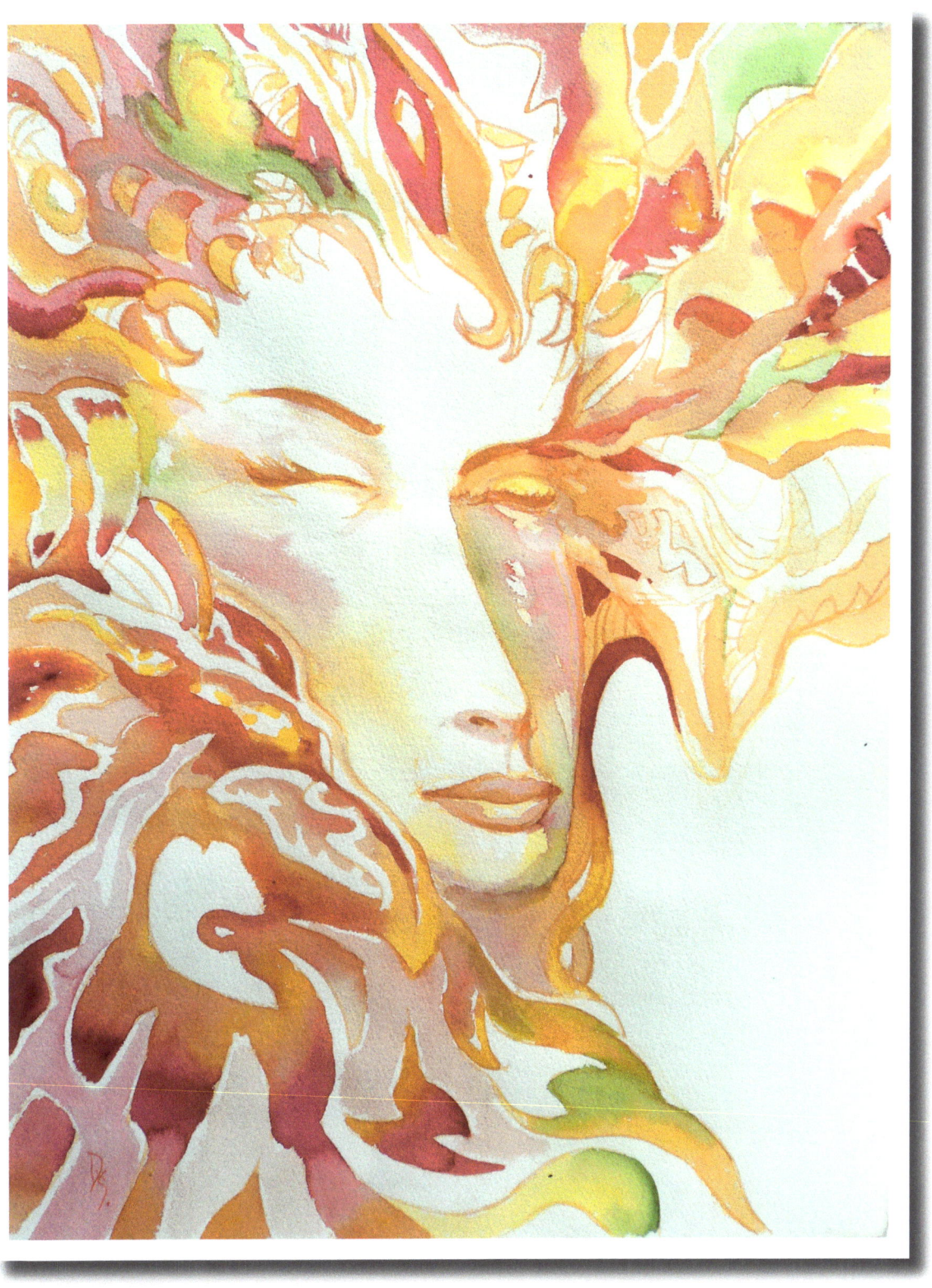

DREAMING LIGHT

Reality is merely an illusion, albeit a very persistent one.

Albert Einstein

The Emperor - 2010, watercolor

THE FANTASY ART OF D X STONE

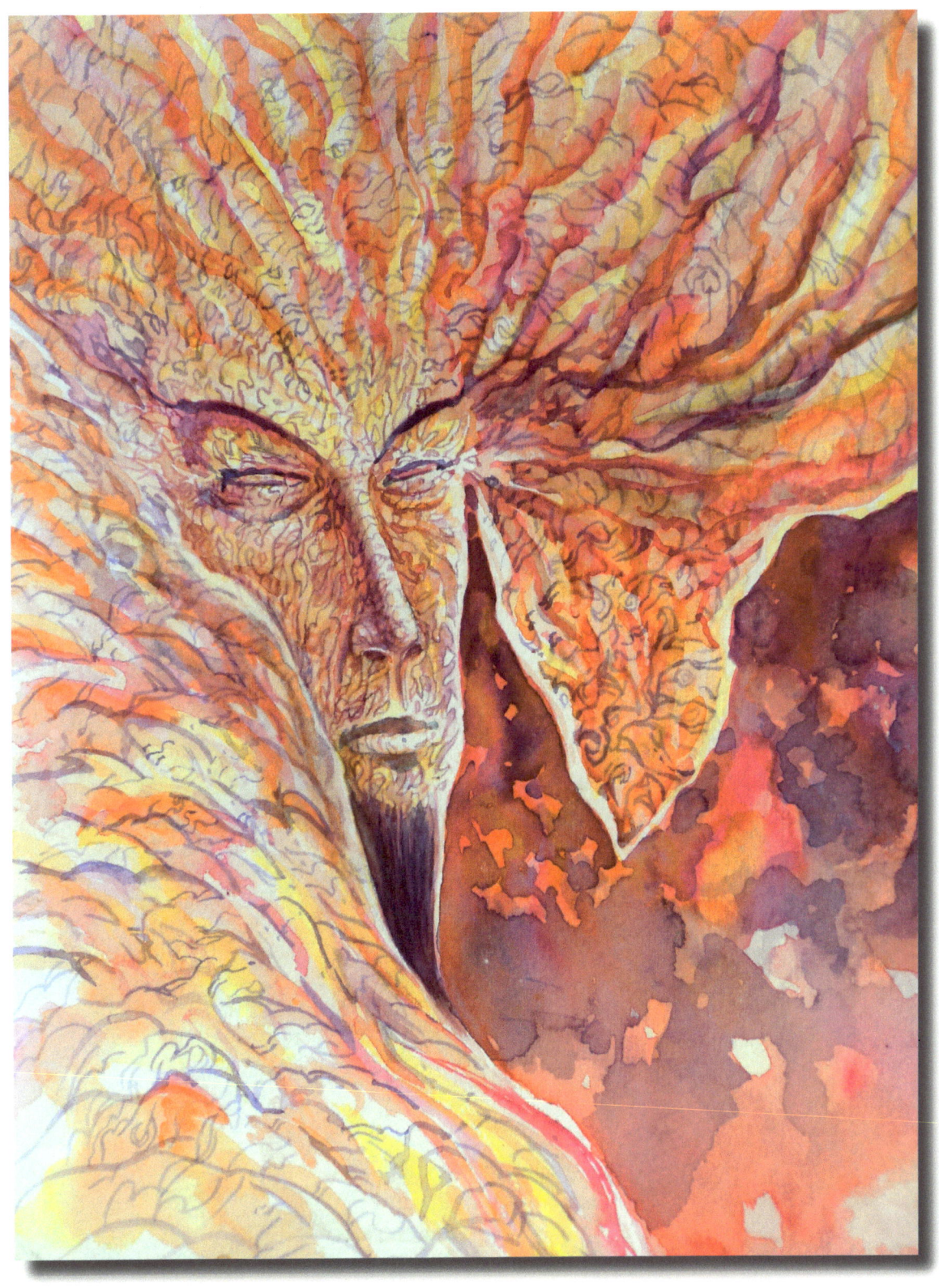

DREAMING LIGHT

Dreams are more real than reality itself, they're closer to the self.

Gao Xingjian

Whatever satisfies the soul is truth.

Walt Whitman

He who trims himself to suit everyone will soon whittle himself away.

Raymond Hull

Life is only a dream and we are the imagination of ourselves.

Bill Hicks

God has given you one face, and you make yourself another.

William Shakespeare

God and other artists are always a little obscure.

Oscar Wilde

I See Your Face Everywhere - 2007, watercolor

THE FANTASY ART OF D X STONE

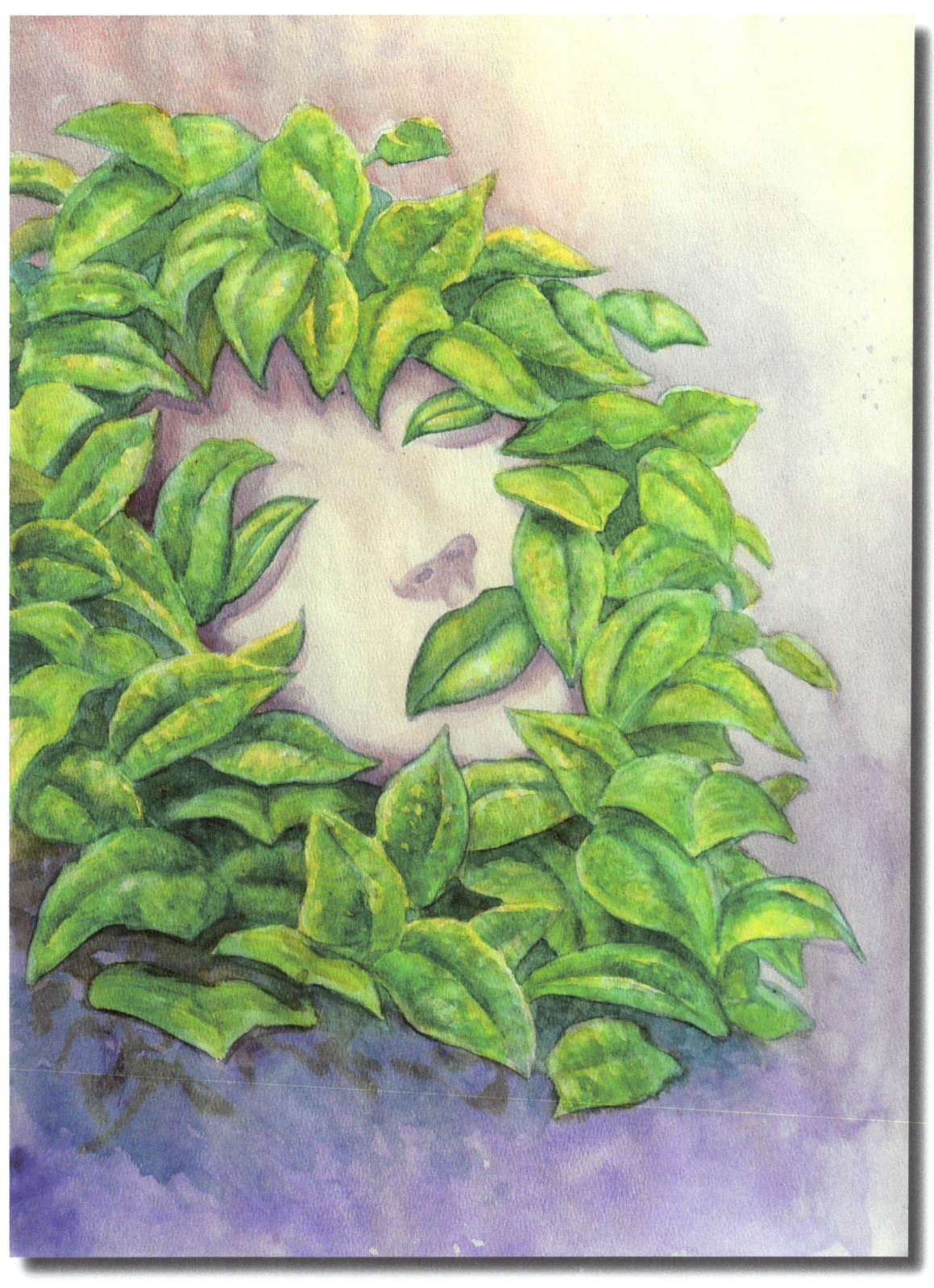

DREAMING LIGHT

If your life seems like a nightmare it's because you're afraid of your own dreams.

Carl Gustav Jung

The cave you fear to enter
holds the treasure you seek.

Gods suppressed become devils, and often
it is these devils whom we first encounter
when we turn inward.

Joseph Campbell

Serpentine - 1986, oil on canvas

THE FANTASY ART OF D X STONE

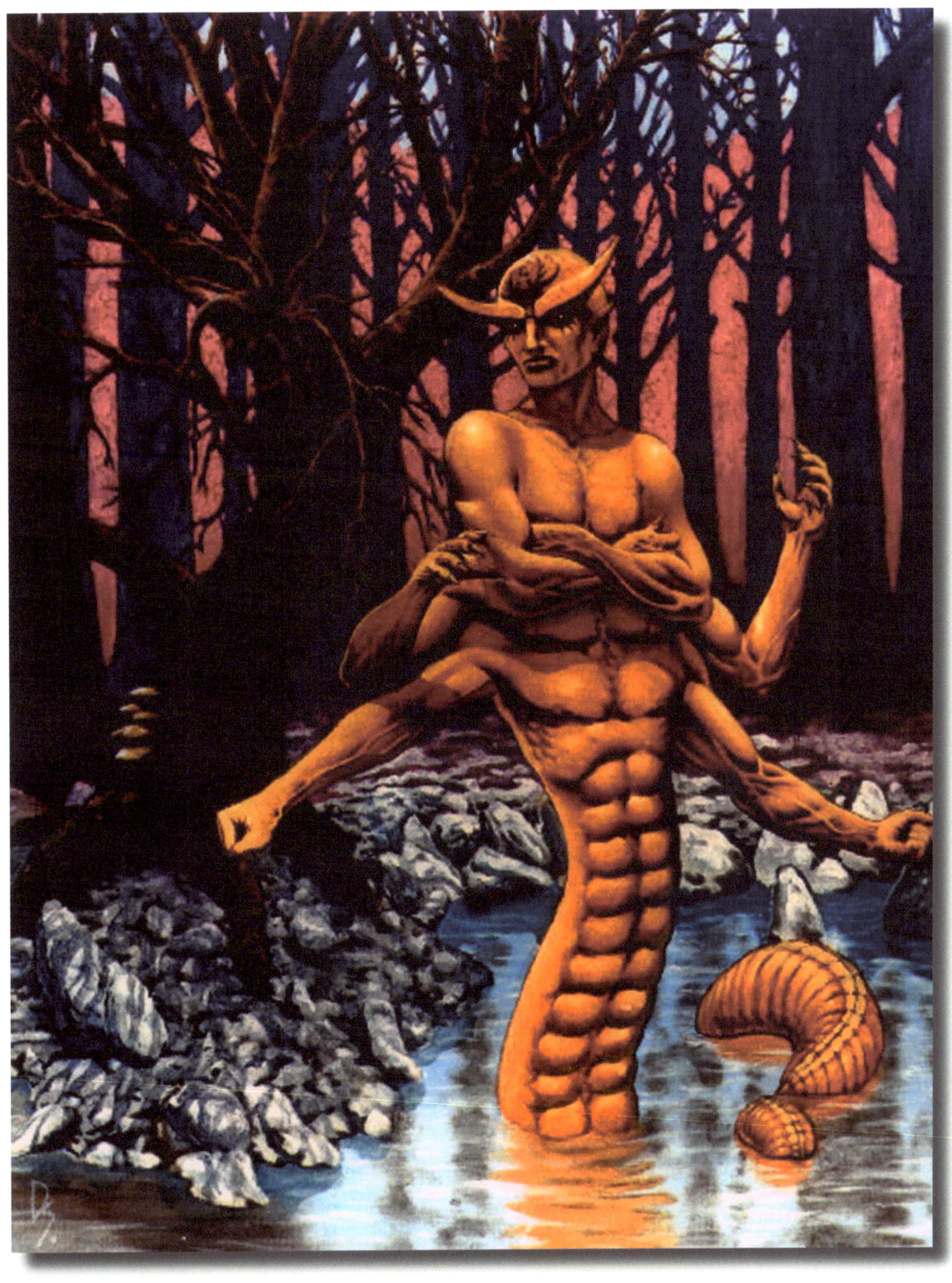

DREAMING LIGHT

Art evokes the mystery without which the world would not exist.

*

If the dream is a translation of waking life, waking life is also a translation of the dream.

*

The mind loves the unknown. It loves images whose meaning is unknown, since the meaning of the mind itself is unknown.

Rene Magritte

Thunderhead - 1999, pencil

THE FANTASY ART OF D X STONE

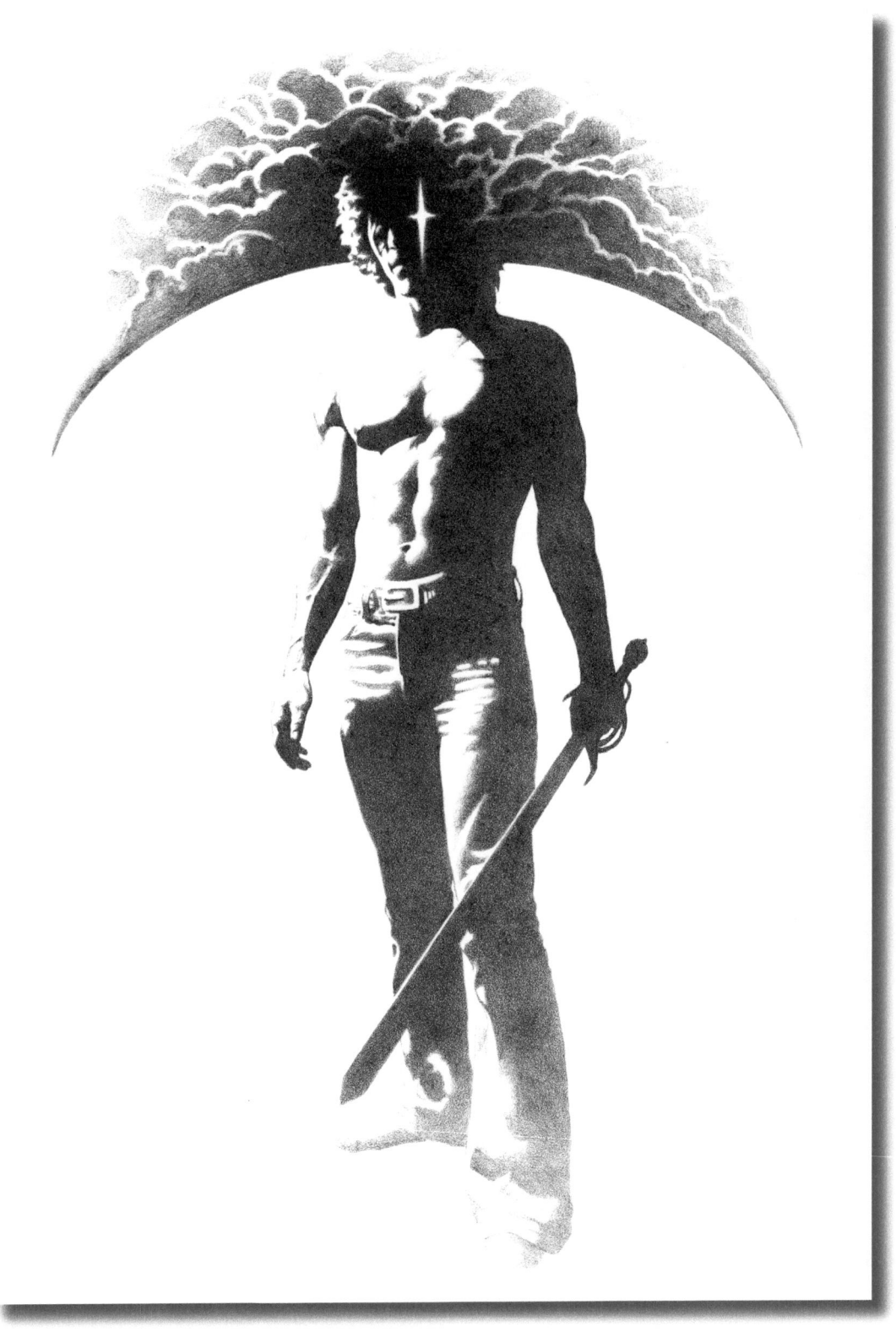

DREAMING LIGHT

"How puzzling all these changes are! I'm never sure what I'm going to be, from one minute to another."

"I have seen so many extra ordinary things, nothing seems extraordinary any more."

"It would be so nice if something made sense for a change."

"It was much pleasanter at home," thought poor Alice, "when one wasn't always growing larger and smaller, and being ordered about by mice and rabbits. I almost wish I hadn't gone down the rabbit-hole–and yet–and yet–..."

Lewis Carroll

Freefall - 1985, oil on canvas

THE FANTASY ART OF D X STONE

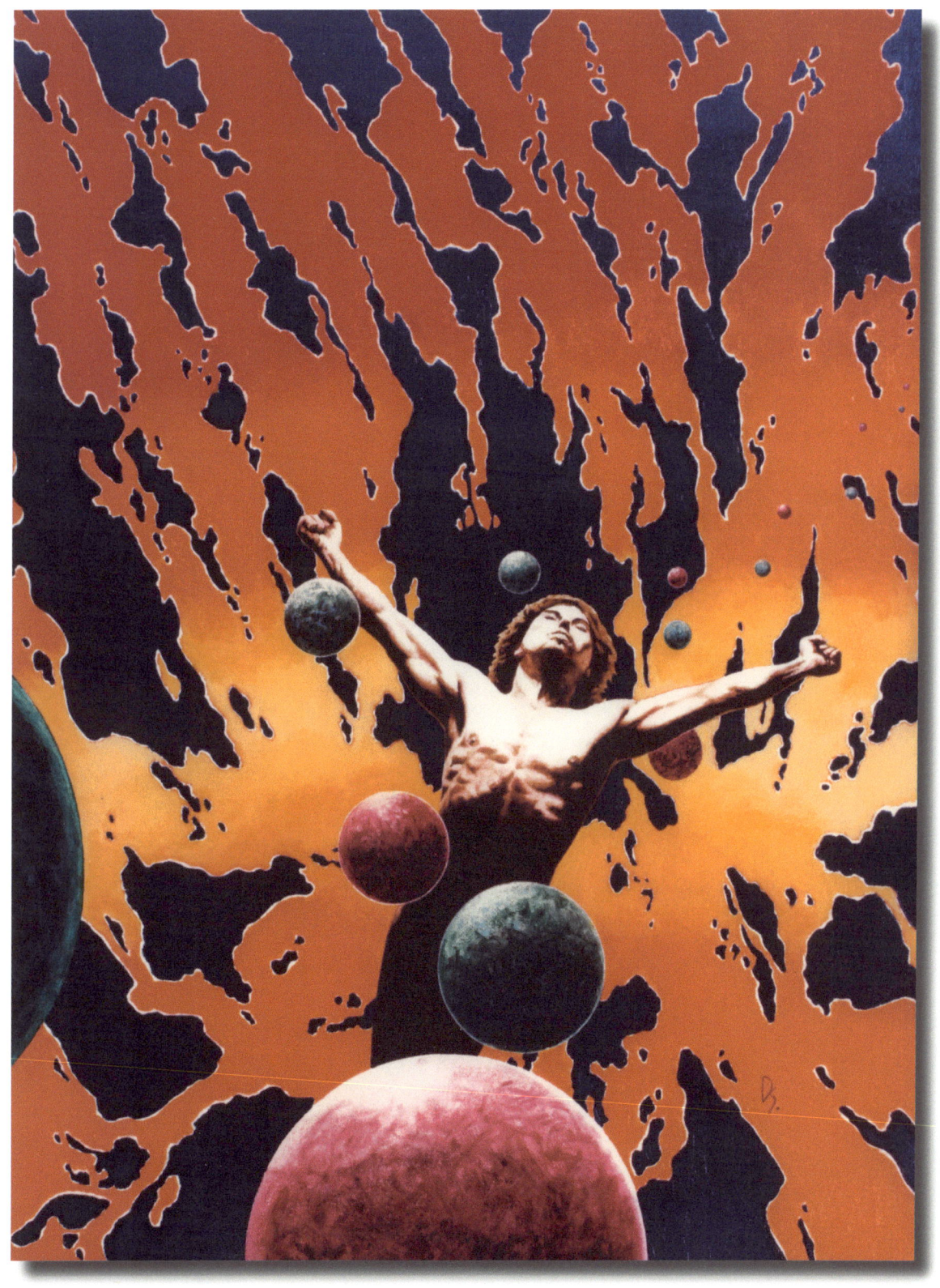

DREAMING LIGHT

"You know that Voight-Kampf test of yours? Have you ever taken that test yourself?"

The truth is overrated. Avoid it at all costs.

Tom Waits

The only real failure in life is not to be true to the best one knows.

Buddha

We all wear masks, and the time comes when we cannot remove them without removing some of our own skin.

André Berthiaume

For once you have tasted flight you will walk the earth with your eyes turned skywards, for there you have been and there you will long to return.

Leonardo da Vinci

You must have control of the authorship of your own destiny. The pen that writes your life story must be held in your own hand.

Irene C. Kassorla

Buy a one-way ticket on Greyhound Bus Lines. Bring only what you can carry in your own two hands. Fasten your seat belts, make sure your seats are in a full, upright position, and spew indigo from your third eye.

Ann Magnuson

Rachel to Deckard, Blade Runner

Freefall III – 1995, digital media

THE FANTASY ART OF D X STONE

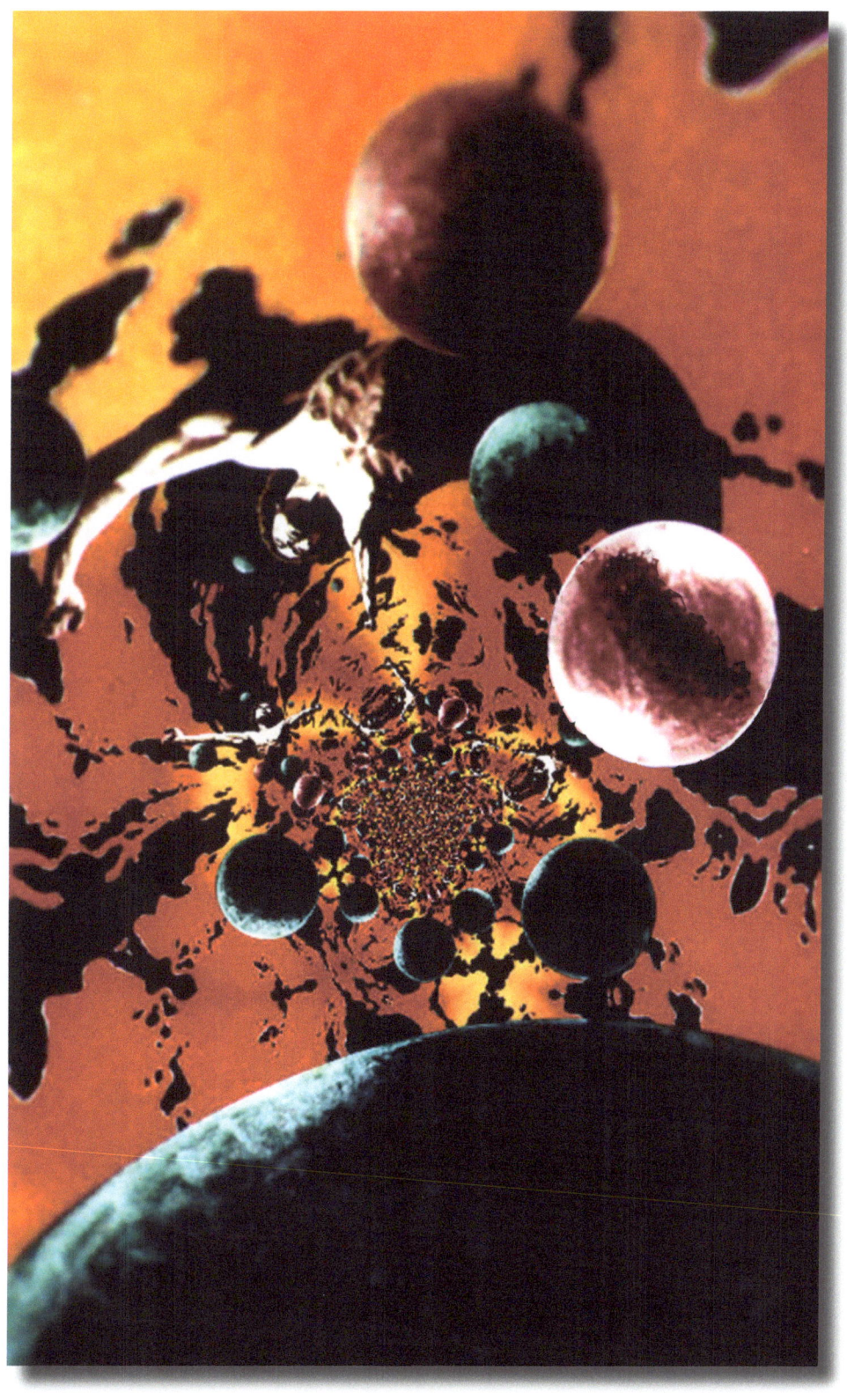

DREAMING LIGHT

Freefall IV – 1995, digital media

THE FANTASY ART OF D X STONE

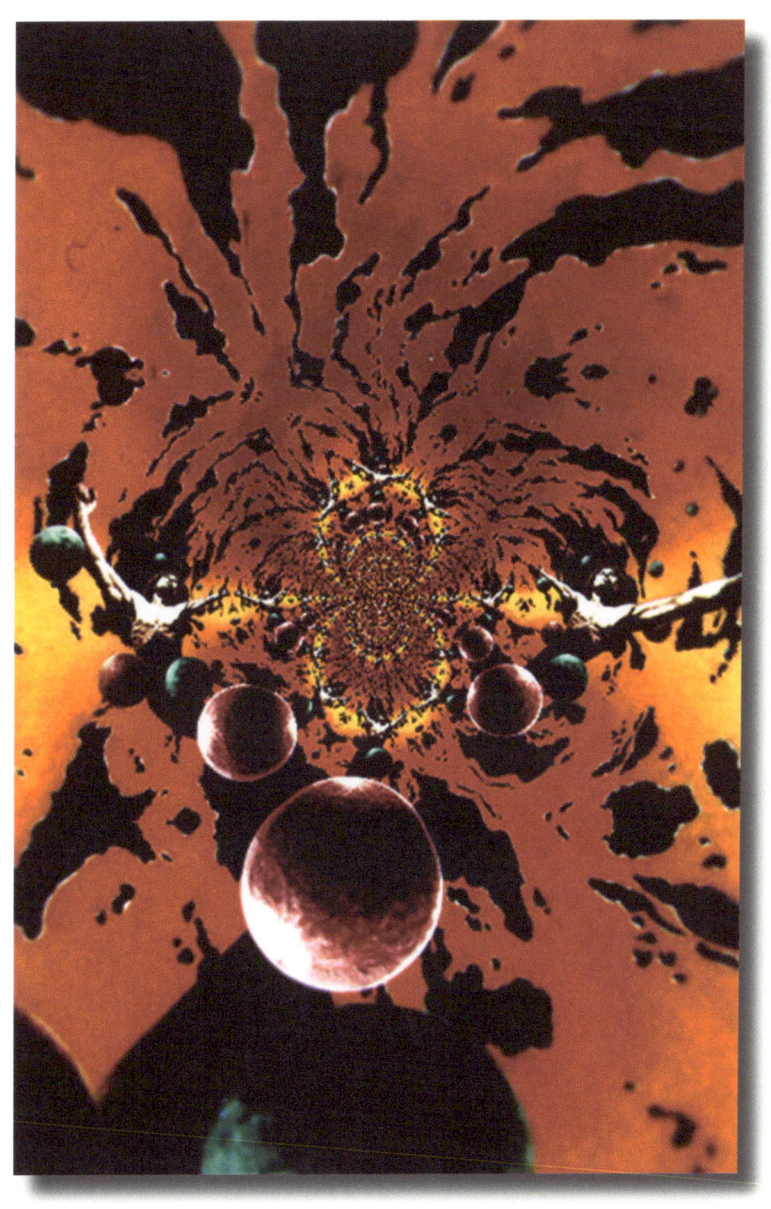

DREAMING LIGHT

"Do you know, I always thought unicorns were fabulous monsters, too? I never saw one alive before!"

Well, now that we have seen each other," said the unicorn, "if you'll believe in me, I'll believe in you."

Lewis Carroll

Freefall VI - 1995, digital media

THE FANTASY ART OF D X STONE

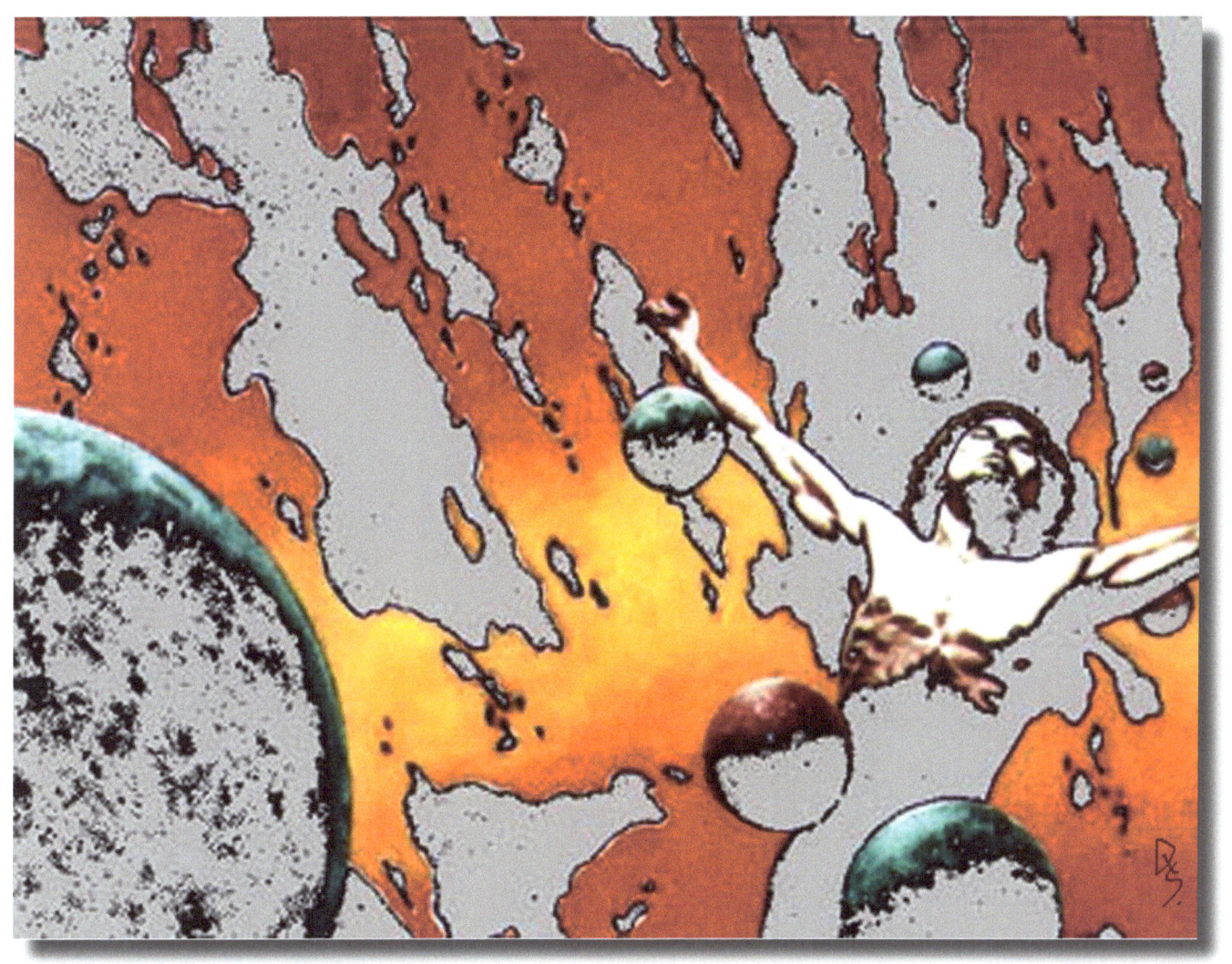

DREAMING LIGHT

If you do follow your bliss you put yourself on a kind of track that has been there all the while, waiting for you, and the life that you ought to be living is the one you are living. Follow your bliss and don't be afraid, and doors will open where you didn't know they were going to be.

*

The privilege of a lifetime is being who you are.

Joseph Campbell

I saw the angel in the marble and carved until I set him free.

Michelangelo

The High Priestess - 2009, watercolor

THE FANTASY ART OF D X STONE

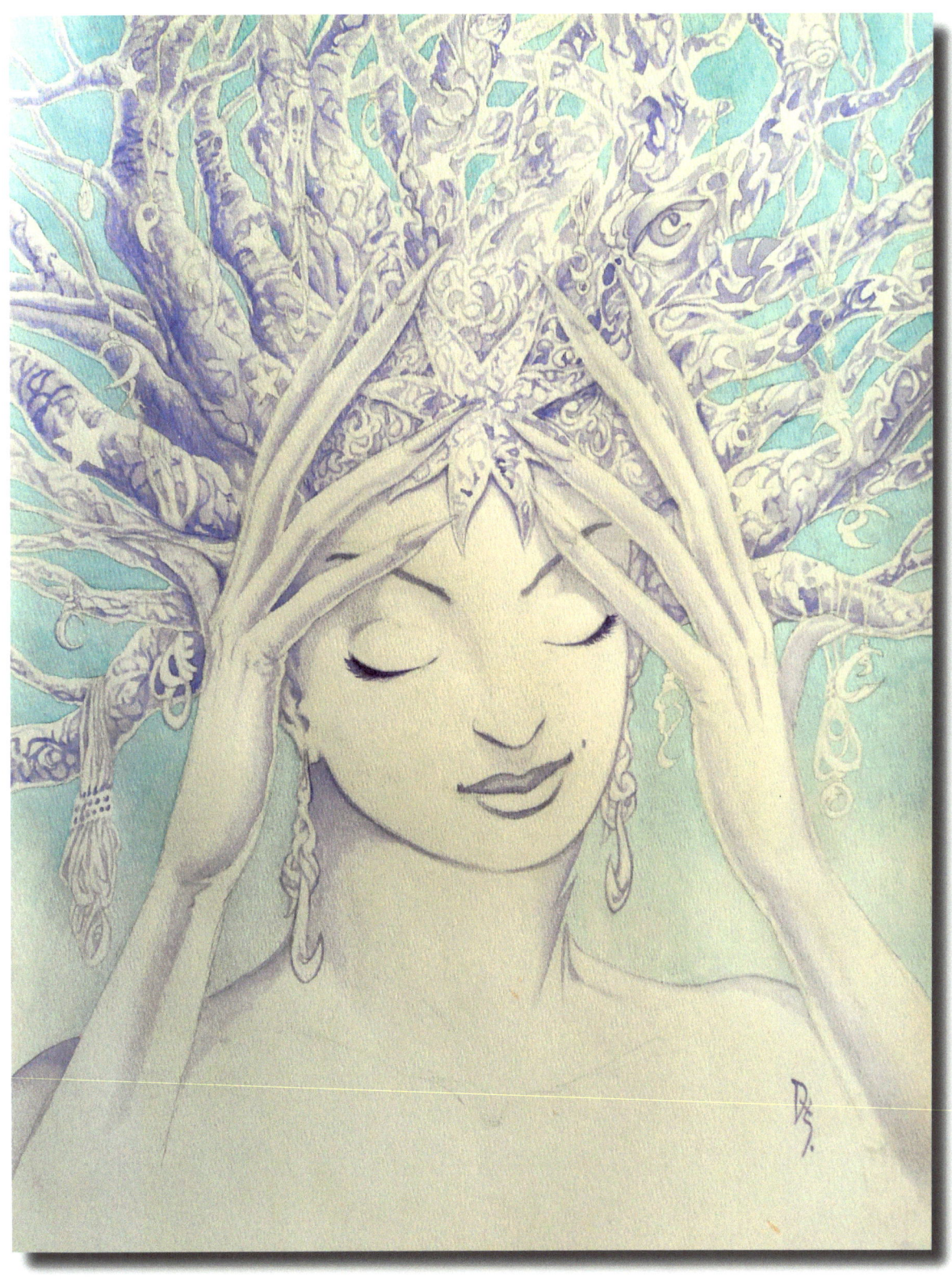

DREAMING LIGHT

Myths are public dreams, dreams are private myths.

Joseph Campbell

Daphne - 1987, oil on canvas

THE FANTASY ART OF D X STONE

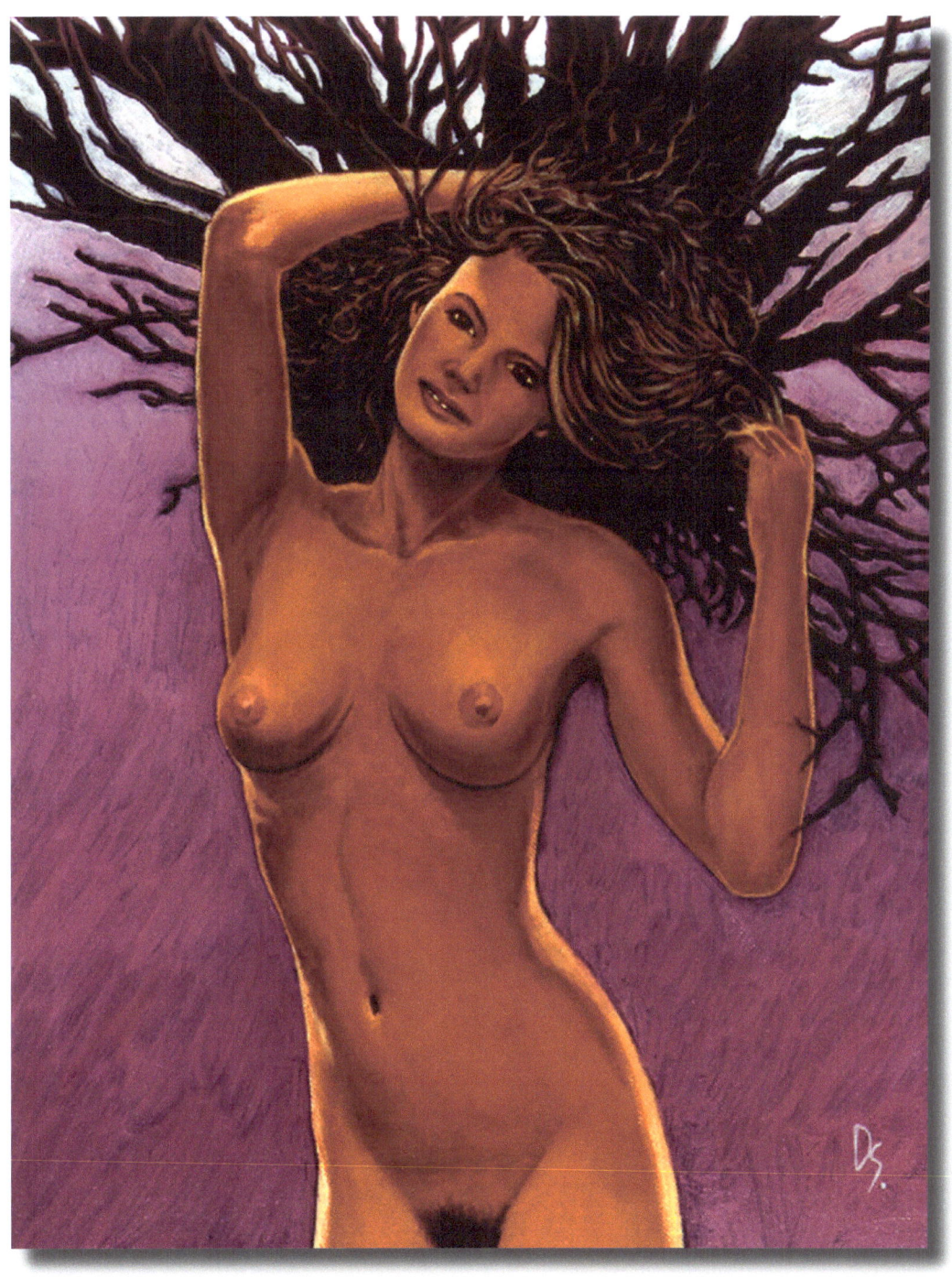

DREAMING LIGHT

Dreaming about being an actress is more exciting then being one.

— Maryilyn Monroe

I dreamed I was a butterfly, flitting around in the sky; then I awoke. Now I wonder: Am I a man who dreamt of being a butterfly, or am I a butterfly dreaming that I am a man?

— Zhuangzi

It is better to be hated for what you are than to be loved for something you are not.

— Andre Gide

All human beings are also dream beings. Dreaming ties all mankind together.

— Jack Kerouac

it takes courage to grow up and become who you really are.

— e.e. cummings

Golden Girl - 2007, watercolor

THE FANTASY ART OF D X STONE

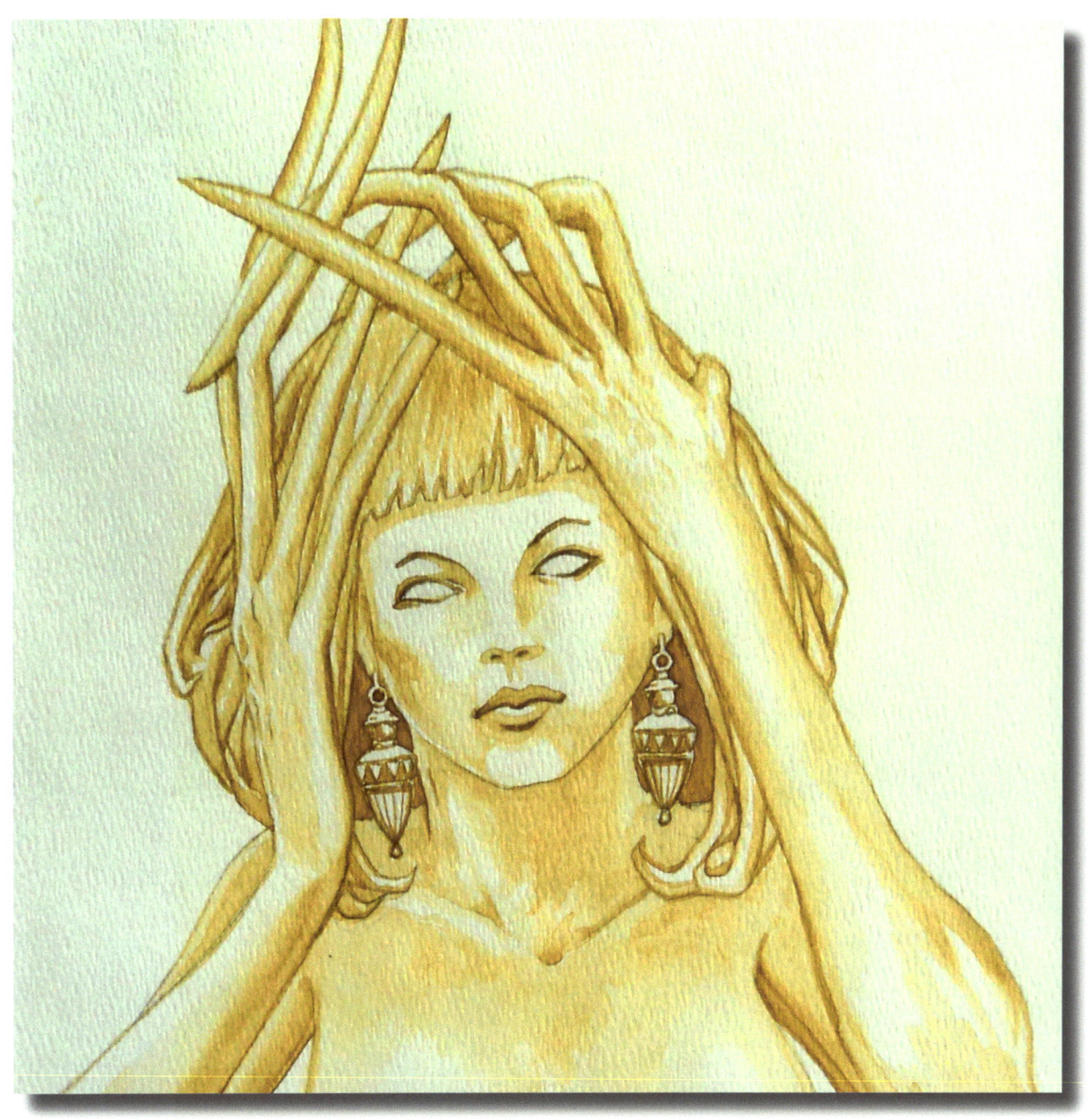

DREAMING LIGHT

The wisest men follow their own direction.

　　　　　　　Euripides

Keep true to the dreams of thy youth.

　　　　　　　Friedrich von Schiller

Human beings have an inalienable right
to invent themselves.
　　　　　　　Homer

Golden Lady - 2007, watercolor

THE FANTASY ART OF D X STONE

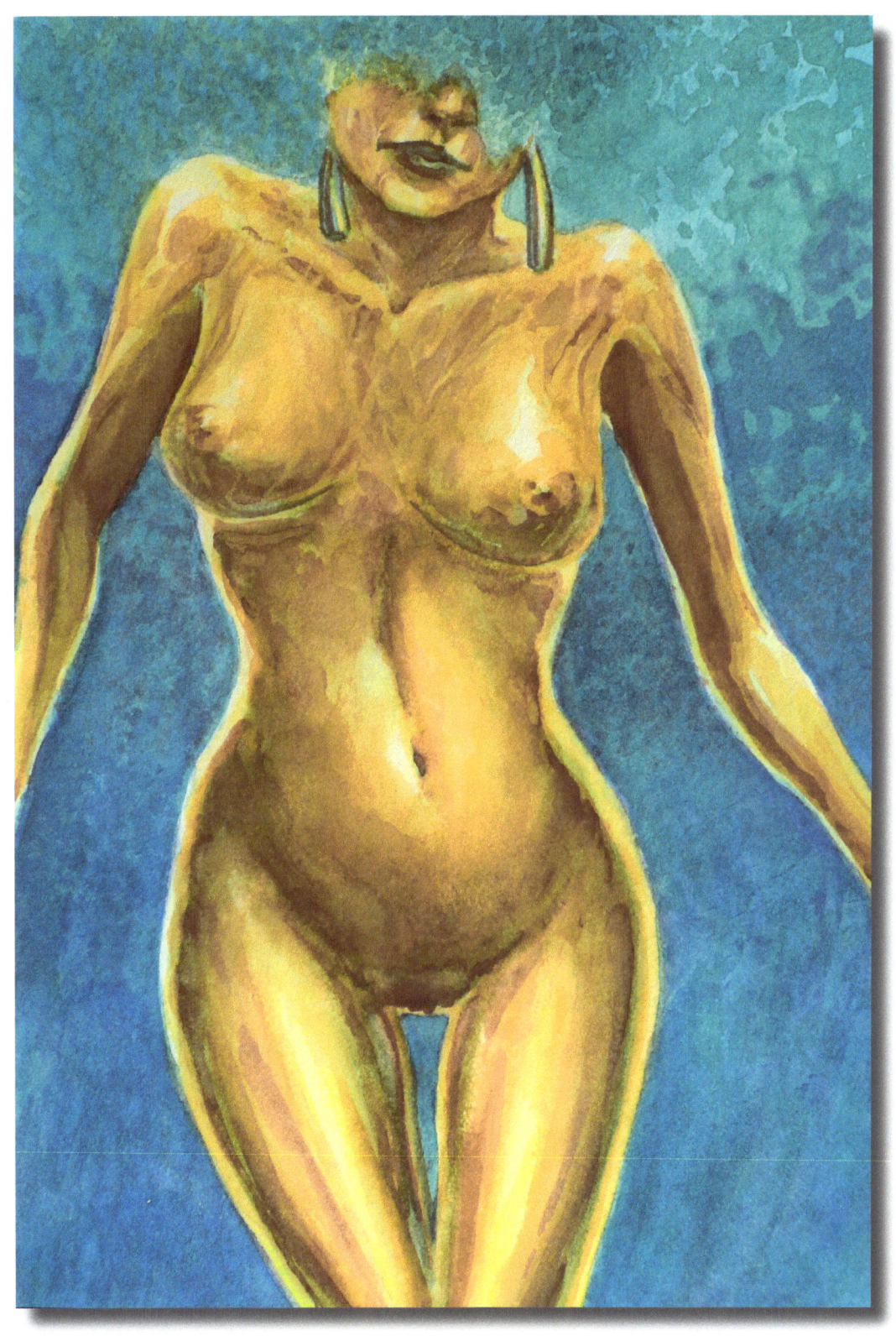

DREAMING LIGHT

Do I contradict myself? Very well, then I contradict myself. I am large, I contain multitudes.

Walt Whitman

At The Freak Clinic - 1976, watercolor and ink

THE FANTASY ART OF D X STONE

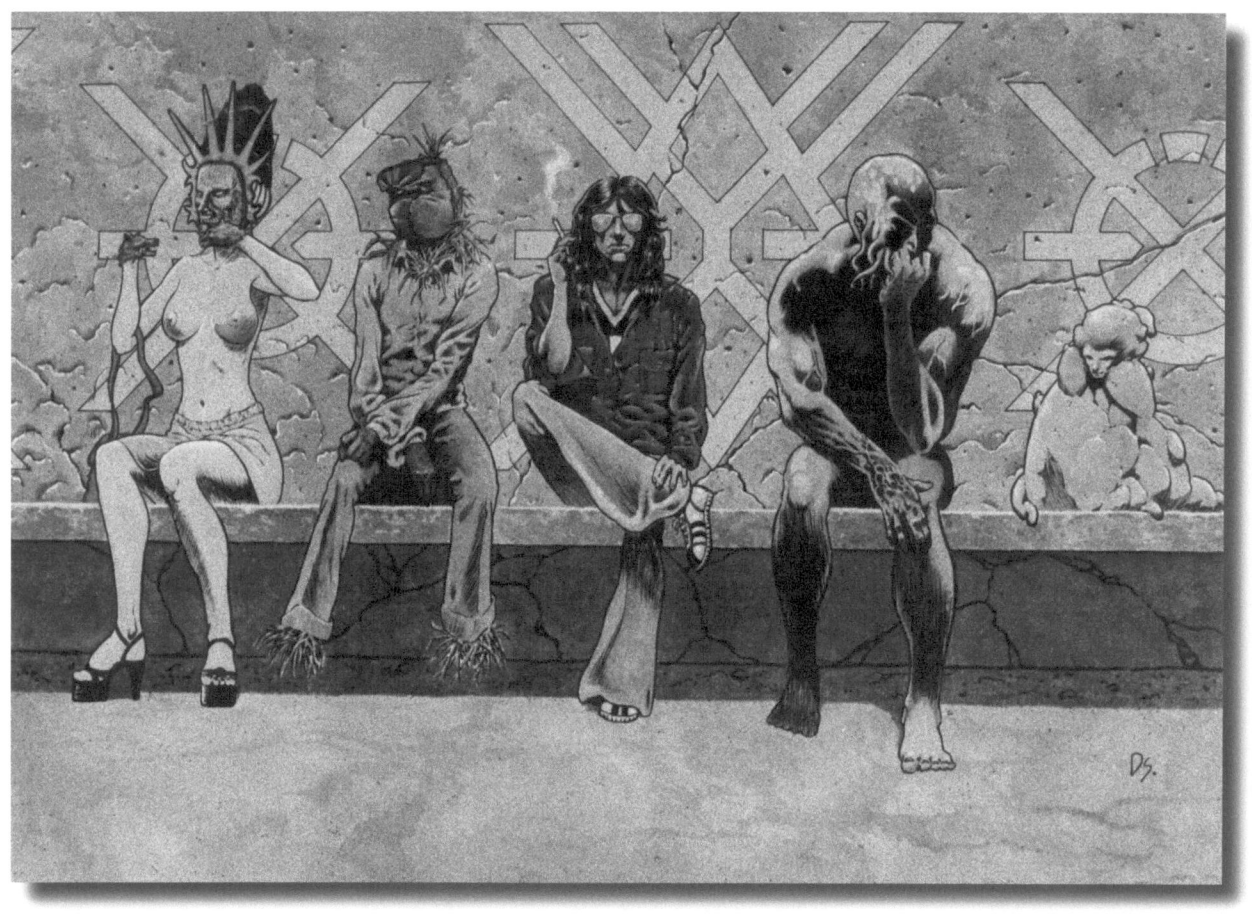

DREAMING LIGHT

I believe in everything until it's disproved. So I believe in fairies, the myths, dragons. It all exists, even if it's in your mind.

John Lennon

Best Pals - 1988, oil on canvas

THE FANTASY ART OF D X STONE

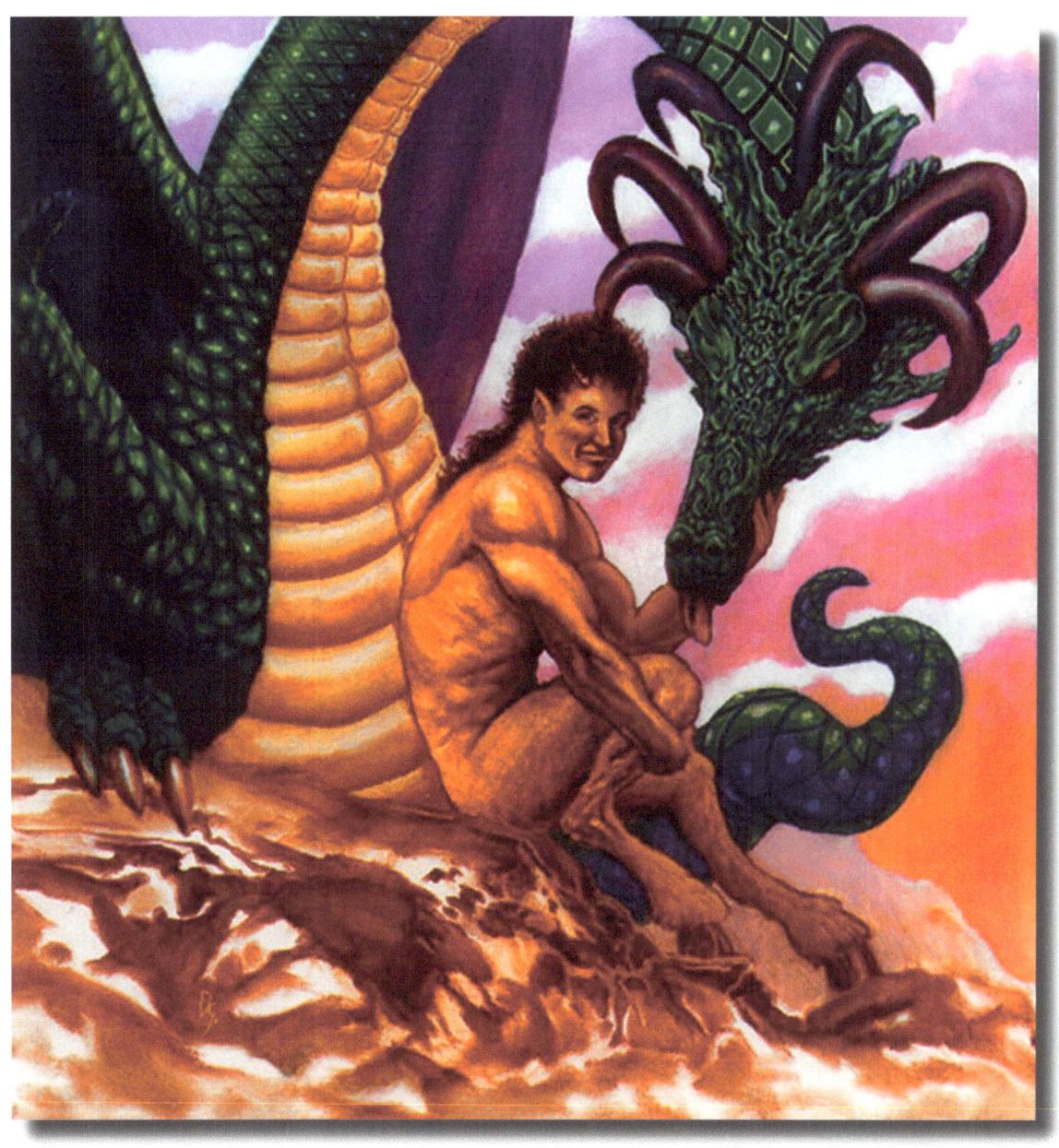

DREAMING LIGHT

It is not the length of life, but the depth.

The earth laughs in flowers.

Dare to live the life you have dreamed for yourself.
Go forward and make your dreams come true.

Ralph Waldo Emerson

Flower - 2008, digital media

THE FANTASY ART OF D X STONE

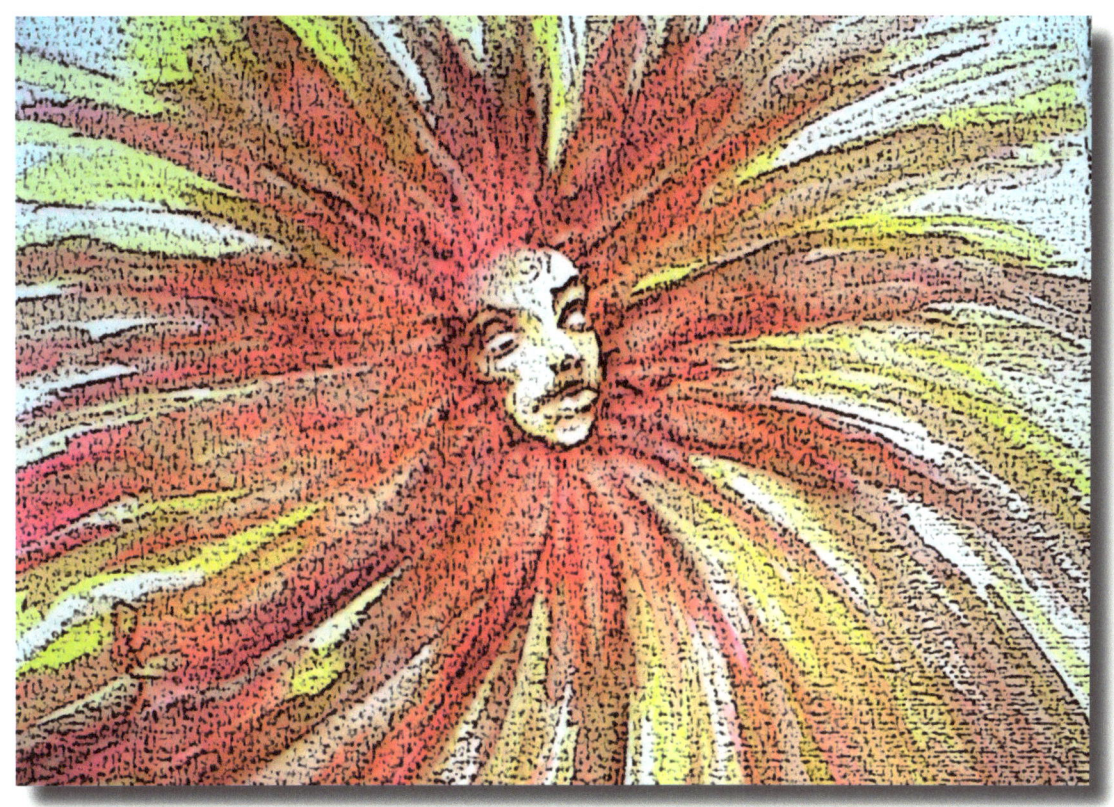

DREAMING LIGHT

> Dream and give yourself permission to envision a You that you choose to be.
>
> Joy Page

> To be yourself in a world that is constantly trying to make you something else is the greatest accomplishment.
>
> Ralph Waldo Emerson

Cliffside - 2007, pastel

THE FANTASY ART OF D X STONE

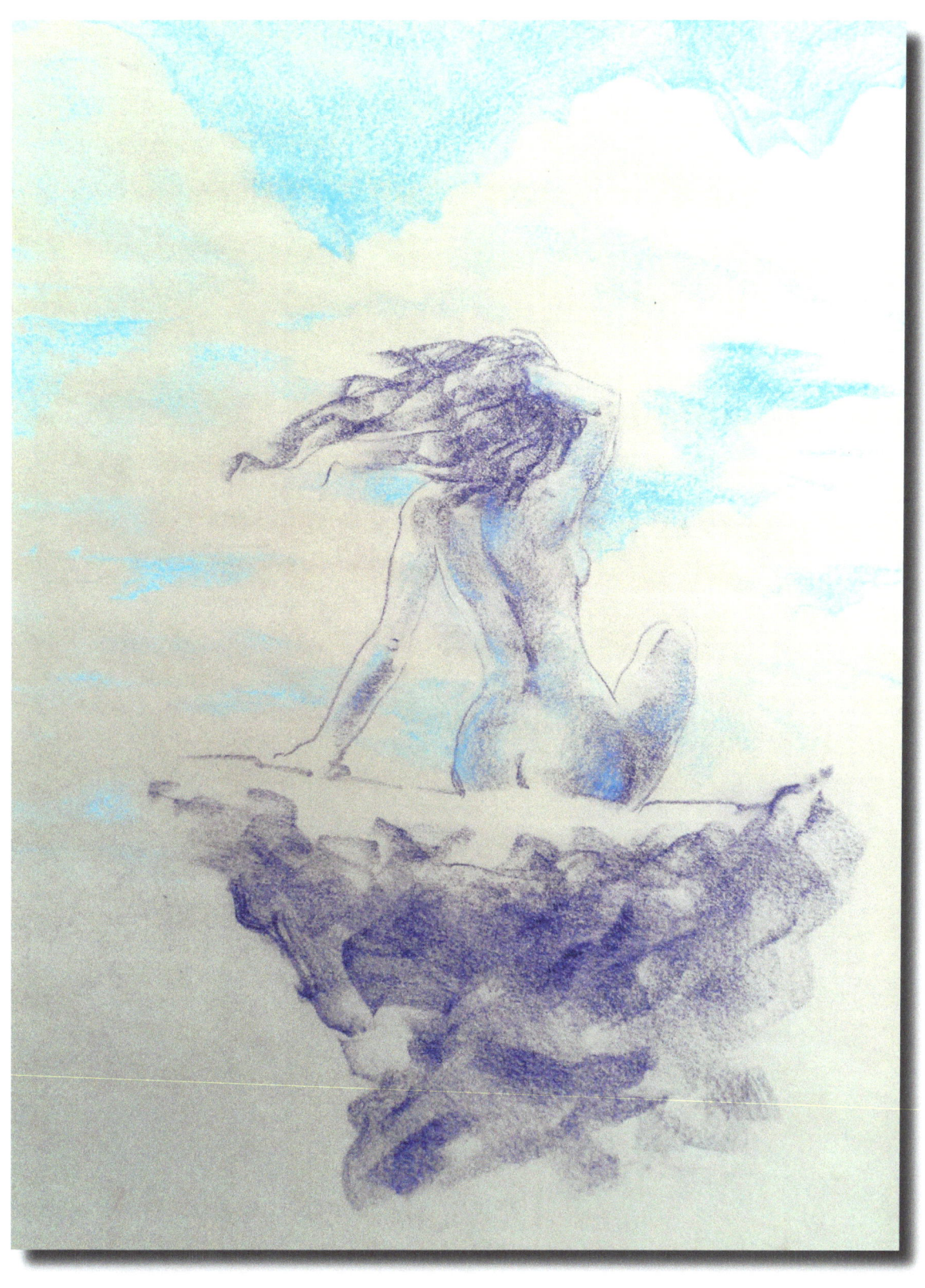

DREAMING LIGHT

If I dream I have you, I have you, For all our joys are but fantastical.

John Donne

Nude - 2007, watercolor

THE FANTASY ART OF D X STONE

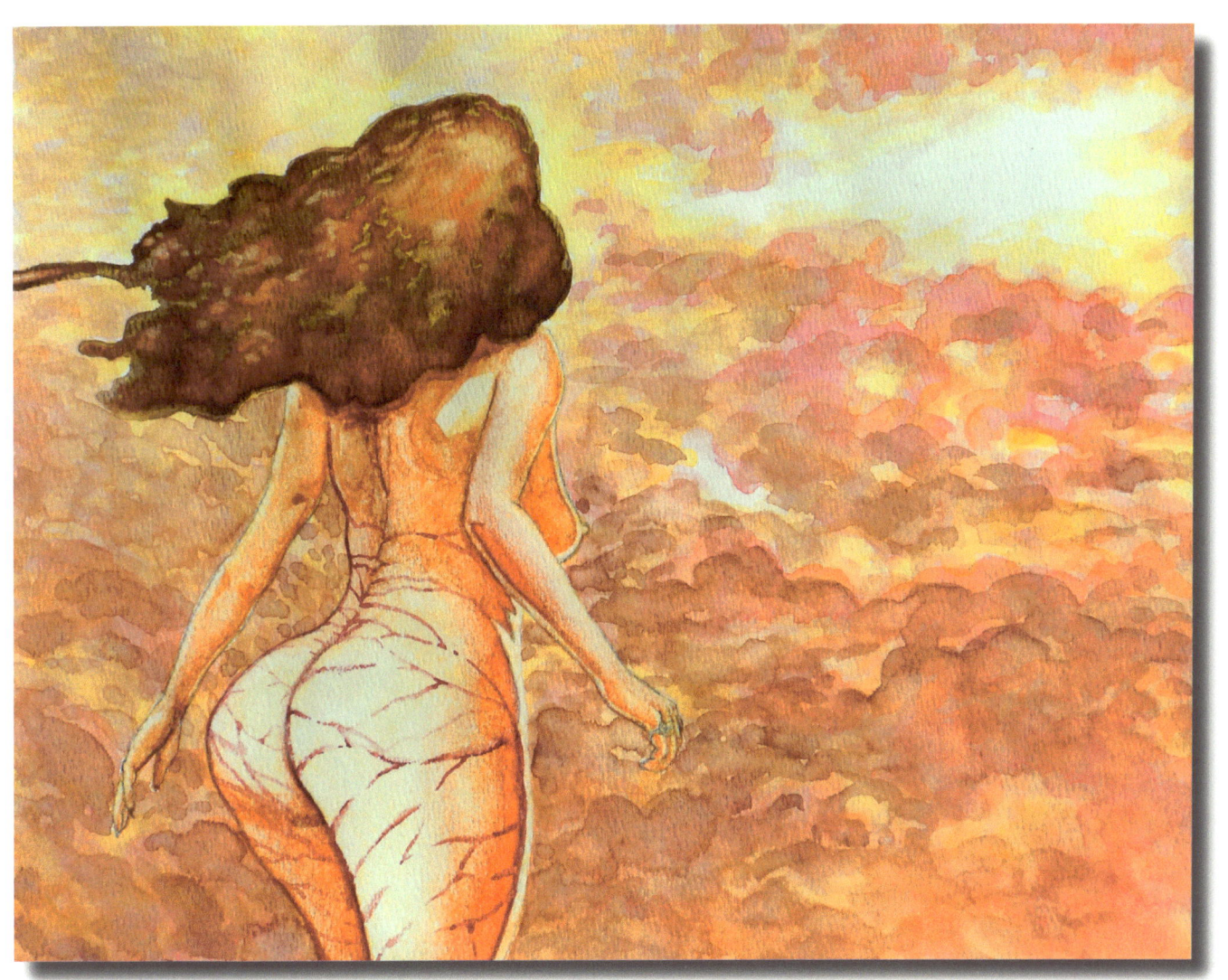

DREAMING LIGHT

I have never listened to anyone who criticized my taste in space travel, sideshows or gorillas. When this occurs, I pack up my dinosaurs and leave the room.

Ray Bradbury

Is it weird in here, or is it just me?

Steven Wright

Creatures – 1983, pen and ink

THE FANTASY ART OF D X STONE

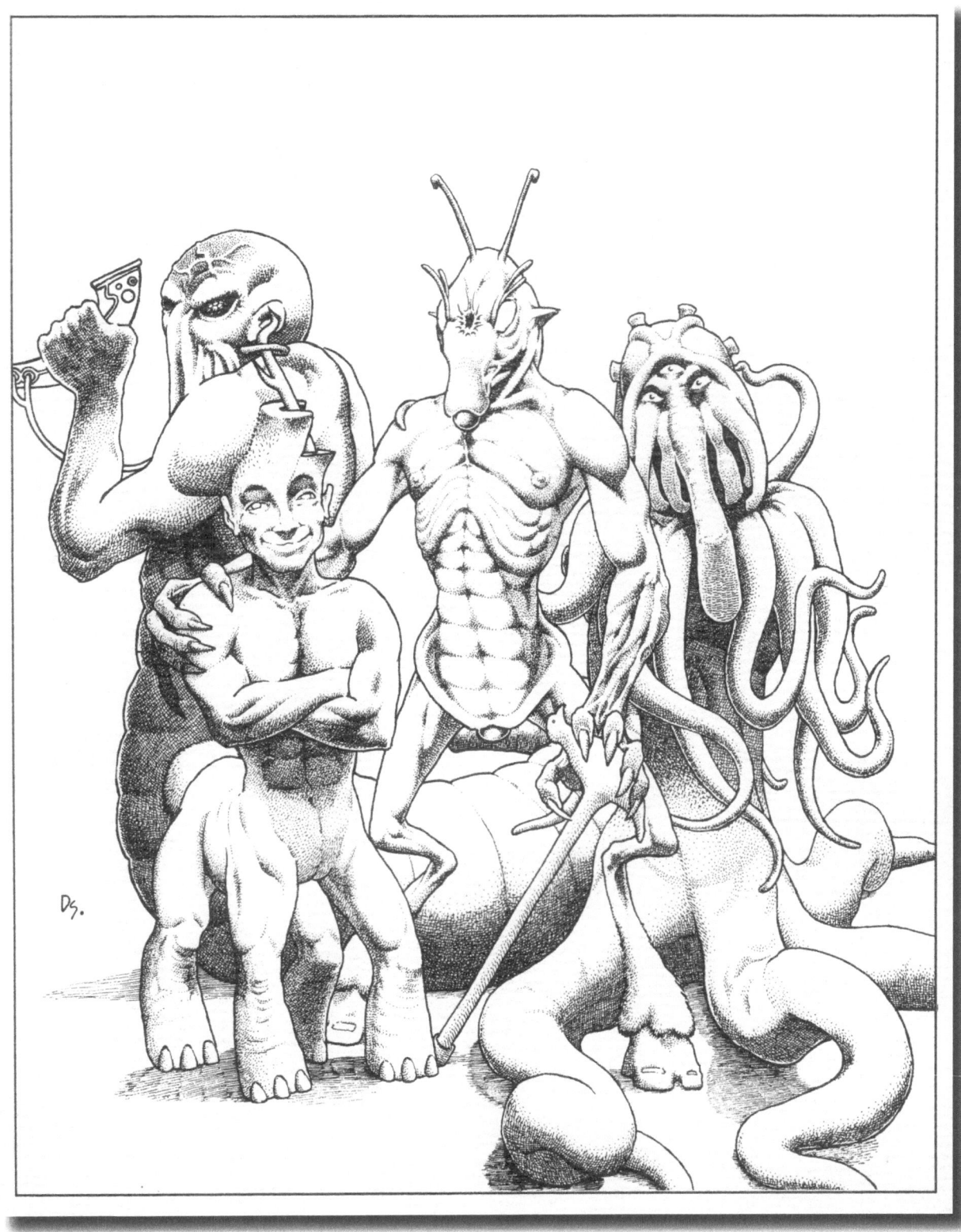

DREAMING LIGHT

Hateful to me as the gates of Hades is that man who hides one thing in his heart and speaks another.

Homer

Most people are other people. Their thoughts are someone else's opinions, their lives a mimicry, their passions a quotation.

Oscar Wilde

Always be a first-rate version of yourself, instead of a second-rate version of somebody else.

Judy Garland

We are so accustomed to disguise ourselves to others that in the end we become disguised to ourselves.

François Duc de La Rochefoucauld

Be who you are and say what you feel, because those who mind don't matter and those who matter don't mind.

Dr. Seuss

Nude – 2011, digital media

THE FANTASY ART OF D X STONE

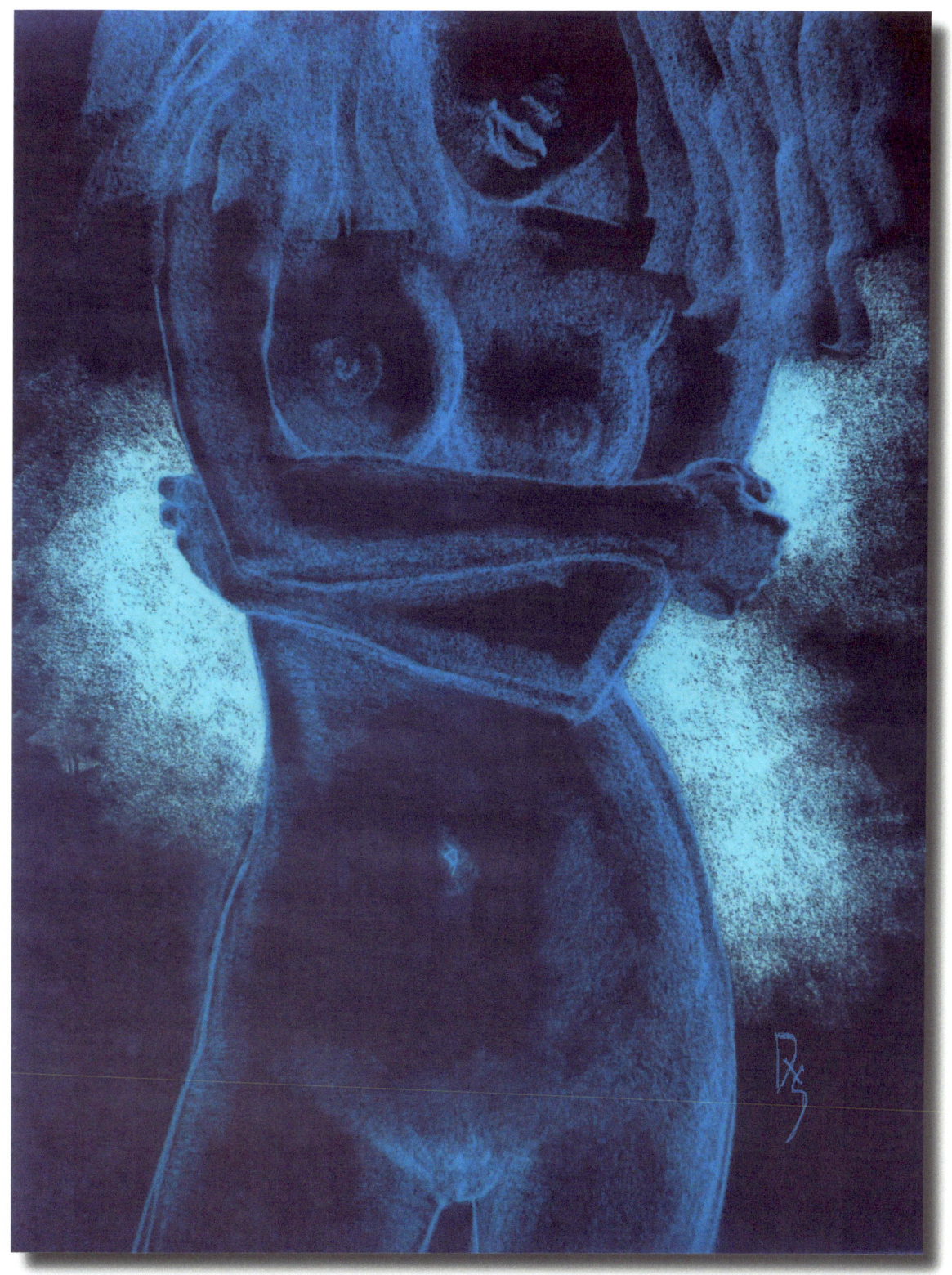

DREAMING LIGHT

There are two ways to live:

You can live as if **NOTHING** is a miracle, or you can live as if **EVERYTHING** is a miracle.

Albert Einstein

Narcissus - 2011, digital media

THE FANTASY ART OF D X STONE

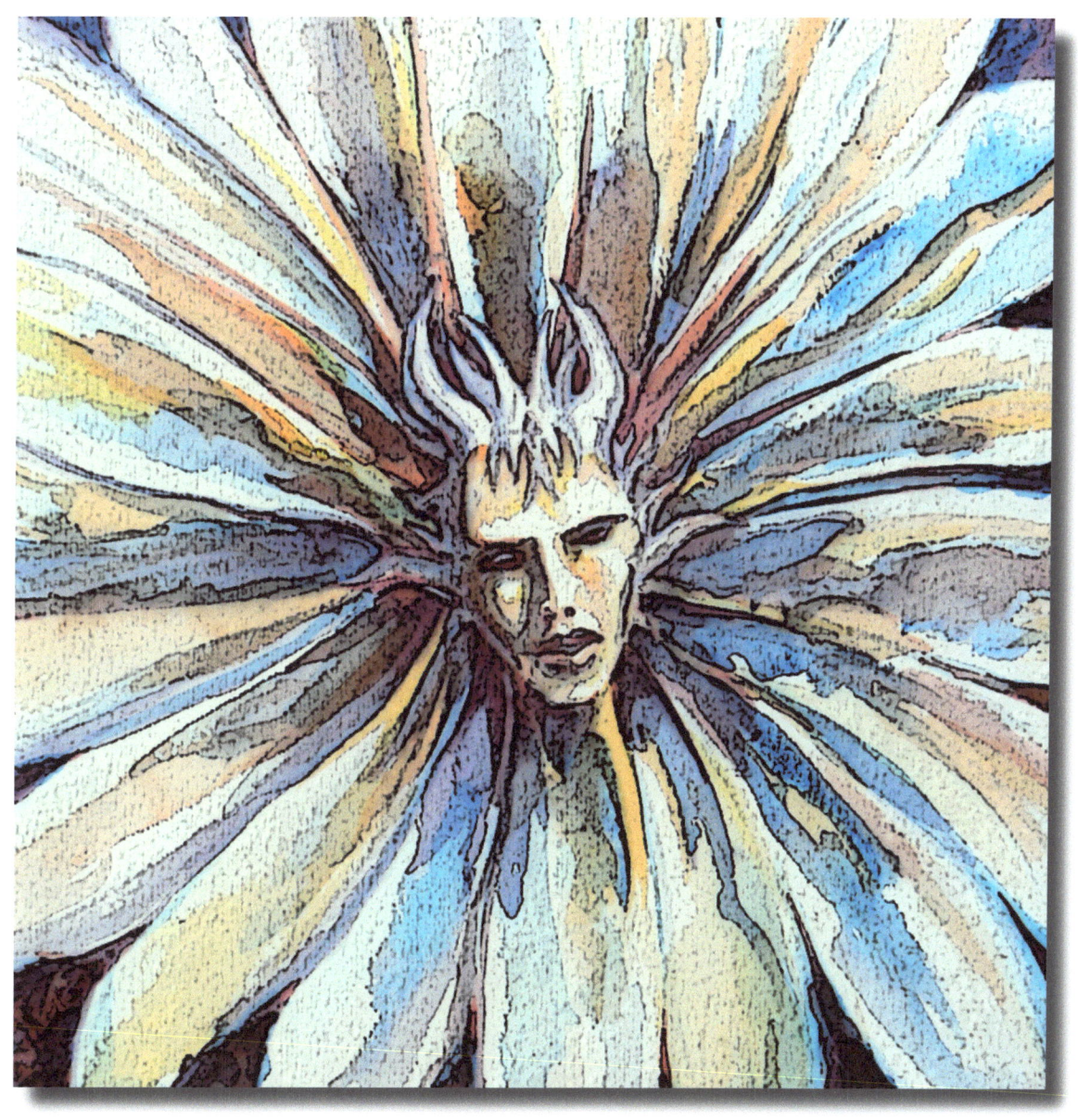

DREAMING LIGHT

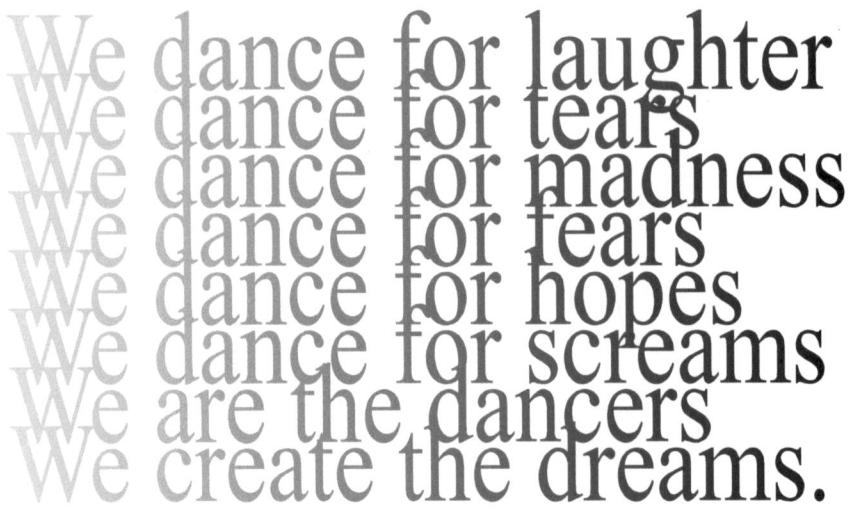

We dance for laughter
We dance for tears
We dance for madness
We dance for tears
We dance for hopes
We dance for screams
We are the dancers
We create the dreams.

Albert Einstein

Nude - 2007, pastel

THE FANTASY ART OF D X STONE

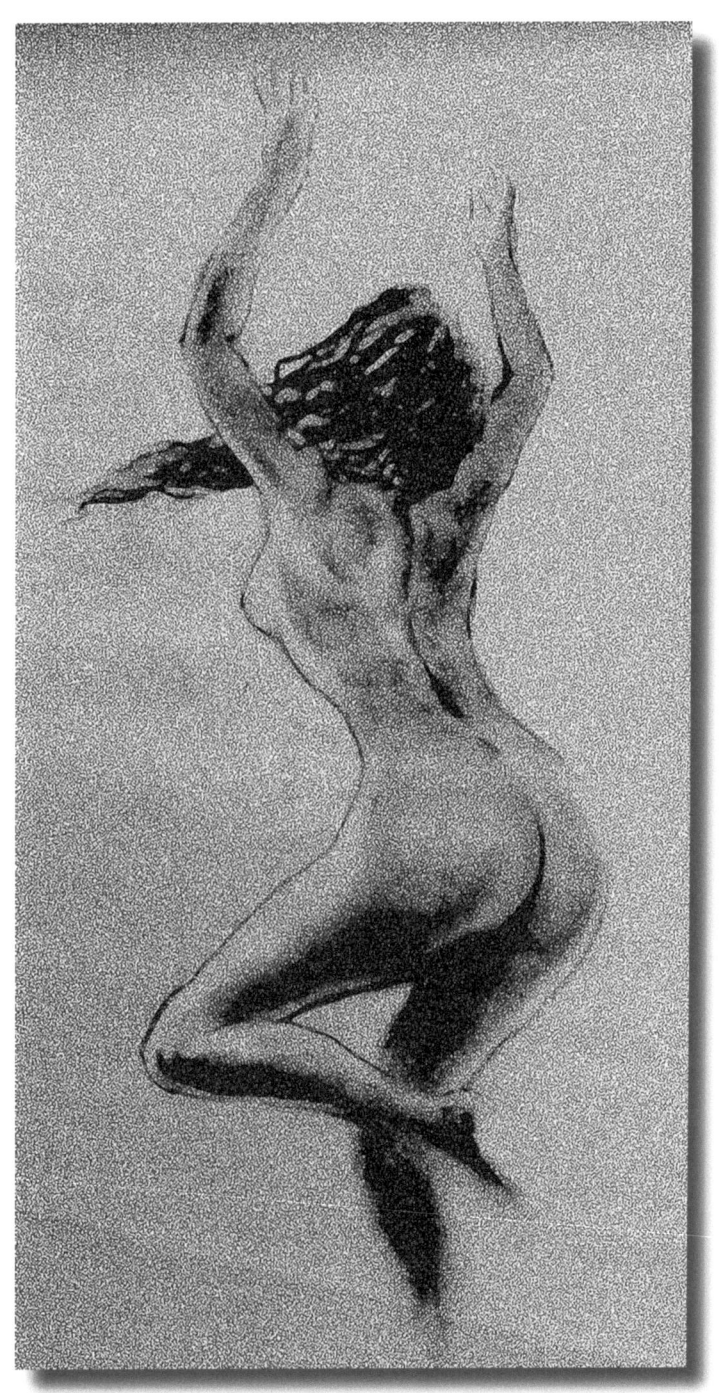

DREAMING LIGHT

Three things cannot be long hidden: the sun, the moon, and the truth.

*

We are what we think. All that we are arises with our thoughts. With our thoughts, we make the world.

Buddha

Contemplation - 2002, pastel

THE FANTASY ART OF D X STONE

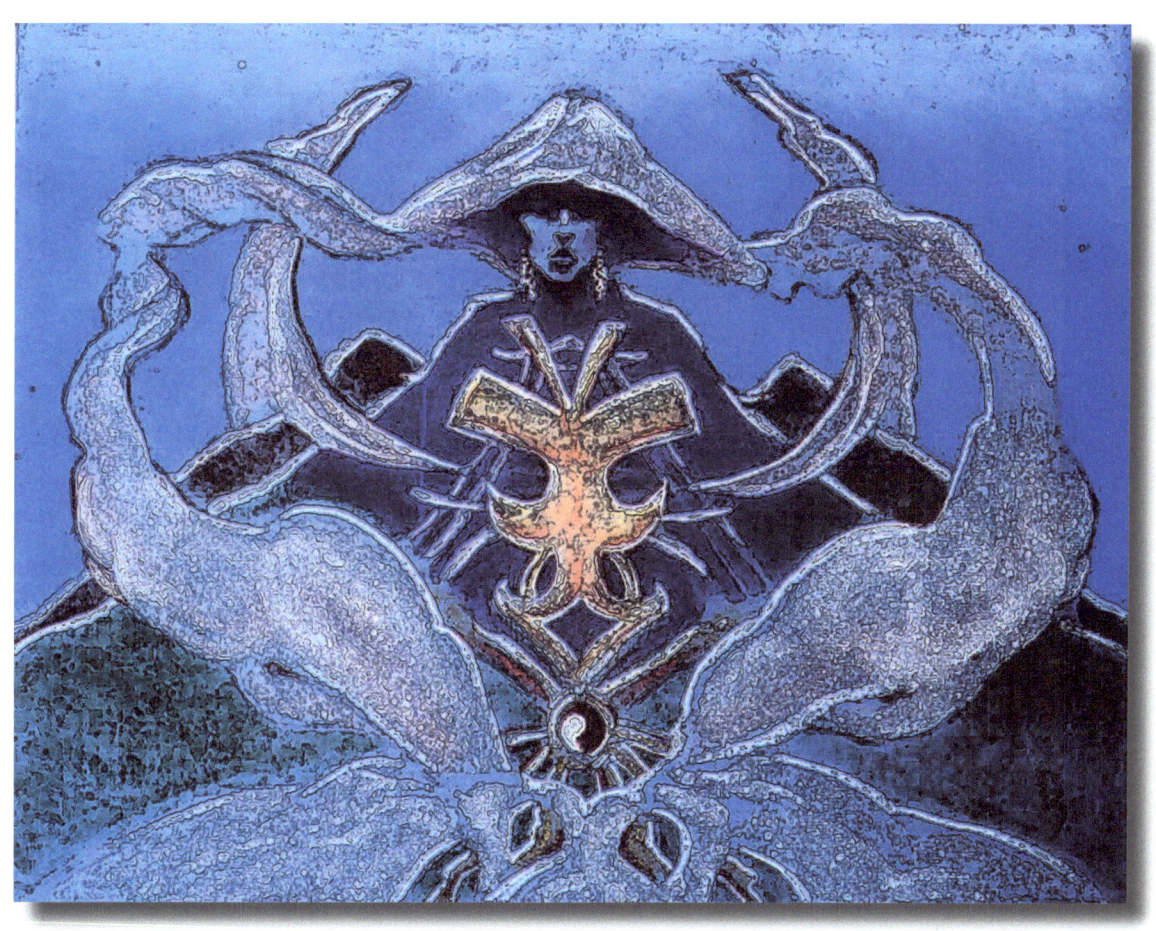

DREAMING LIGHT

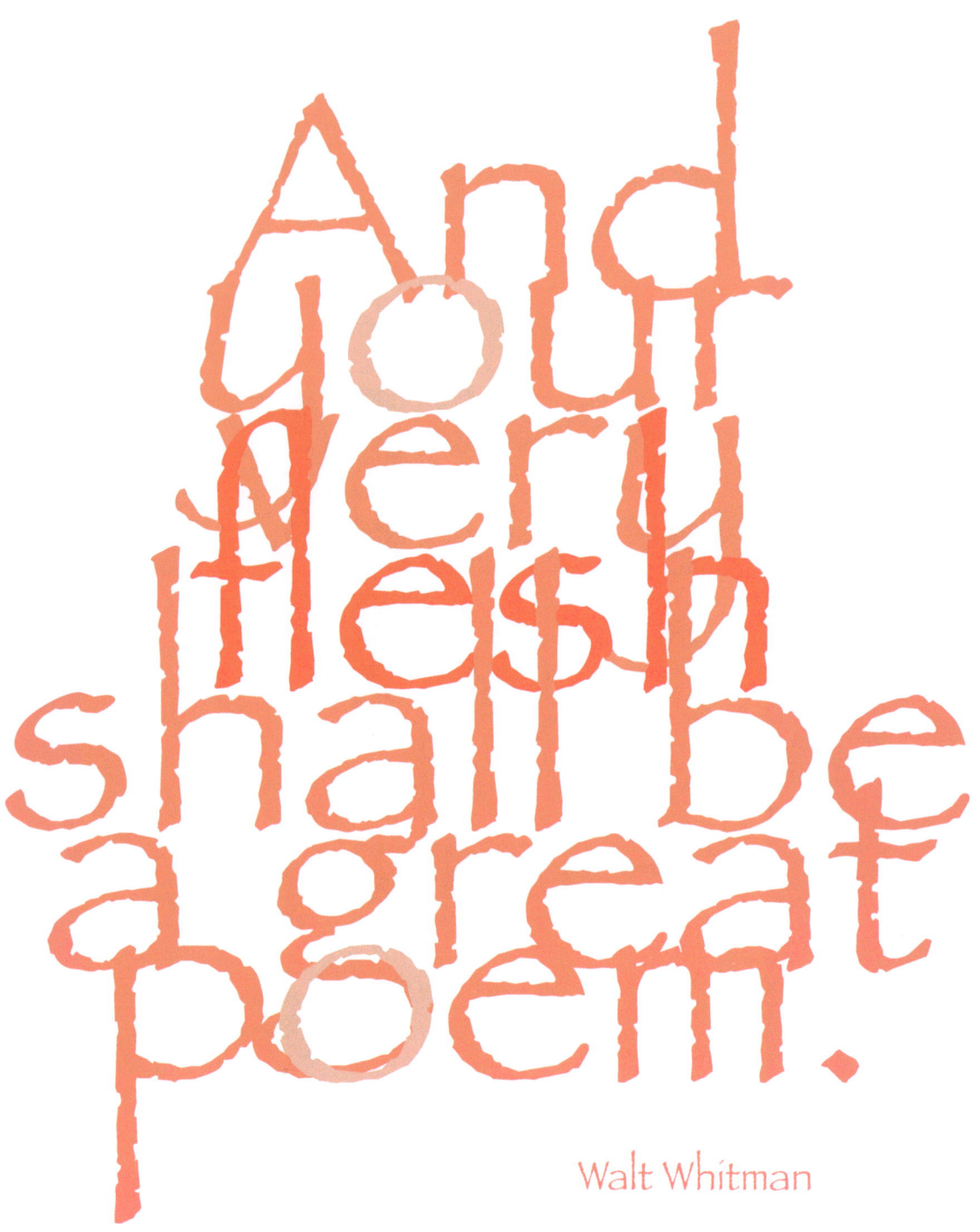

Tigress – 2011, digital media

THE FANTASY ART OF D X STONE

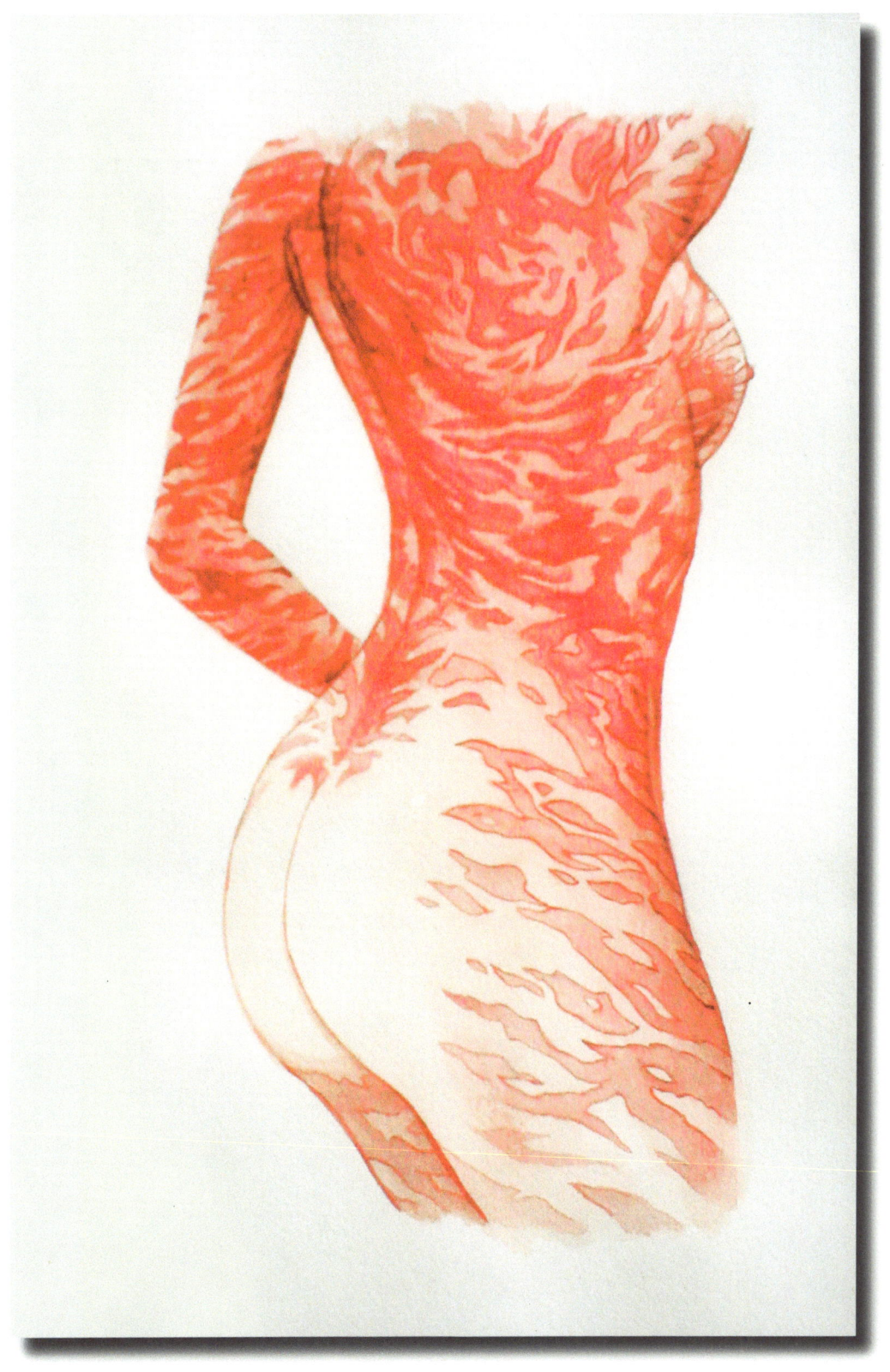

DREAMING LIGHT

I think quotes are very dangerous things.

Kate Bush

All Thumbs - 1985, pencil

THE FANTASY ART OF D X STONE

ABOUT THE ARTIST

D X Stone is an artist, writer, singer/songwriter, humorist and short filmmaker whose painting and other art has appeared almost nowhere at all beyond this two-volume collection of her very best from over 35 years of dreaming deep, and drawing and painting her dreams and nightmares alike.

"If Jung was right, then everything I've ever done has been a self-portrait… which is why I consider myself a work-in-progress, ultimately. Our lives are so long and so varied in experience; we are all works-in-progress, learning, growing, changing… progress being the key word there, hopefully. We are all in a process of continuous transformation, endless becoming. So beautiful, so frightening, so amazing it all is."

She remains ever-hopeful that she may still become a real artist someday, if and when she ever grows up… and that even the darkest horror stories can still have happy endings.

www.ingramcontent.com/pod-product-compliance
Lightning Source LLC
Chambersburg PA
CBHW041816200526
45172CB00026B/563